The international art fair for contemporary objects
Presented by the Crafts Council

25–29 January 2008
At the V&A, London

col lect

SCALA

© Scala Publishers Ltd, 2008
Text © the Crafts Council, 2008

First published in 2008 by
Scala Publishers Ltd
Northburgh House
10 Northburgh St
London EC1V 0AT
Telephone: +44 (0) 20 7490 9900
www.scalapublishers.com

ISBN-13: 978 1 85759 534 5

Project Editor: Esme West
Copy Editor: Helen Armitage
Design: Fraser Muggeridge studio
Printed and bound in Italy

10 9 8 7 6 5 4 3 2 1

With thanks to:

Selection panel
Alun Graves, Curator in the Department of
Sculpture, Metalwork, Ceramics and Glass, V&A
Jorunn Veiteberg, Editor, *Kunsthandverk*
Andrew Renton, Head of Applied Art, Amgueddfa
Cymru – National Museum Wales
David Barrie, Director, The Art Fund
Emma Crichton-Miller, freelance journalist
and writer

Exhibition Management:
Stevie Hassard and Simon Flanagan,
Select Services

Stand Construction:
Stabilo International

Official Shipper:
Gander & White Shipping Ltd

Additional thanks to:
Arts Council England
Own Art
V&A

Crafts Council
44a Pentonville Road
London N1 9BY
UK
Telephone: +44 (0) 20 7278 7700
www.craftscouncil.org.uk
Registered Charity No. 280956

Front cover:
Ray Flavell
Aspiration (detail) 2006
43 × 59 × 59 cm
Glass
Photo: Shannon Tofts
Artist represented by Craftscotland, Edinburgh

Back cover:
Felieke van der Leest
Rocky The Rock Penguin alias The Stork – brooch
2006
10 × 10 × 5 cm
Gold, zircon, textile, plastic
Photo: Eddo Hartmann
Artist represented by Galerie Rob Koudijs, The Netherlands

Front cover flap:
Christopher Robertson
Leaf – teapot 2005
Height 17 cm, diameter 15 cm
Stainless steel, lacquered reinforced phenolic
resin, sterling silver
Photo: Johannes Kuhnen
Artist represented by Australian Contemporary, Australia

Back cover flap:
Ramon Puig Cuyàs
Brooch (from the *Imago Mundi – Tempora si
fuerint nibula* series) 2007
6.5 × 5 × 1 cm
Silver, plastic, wood, volcanic stone, nickel silver,
acrylic paint
Photo: Ramon Puig Cuyàs
Artist represented by Alternatives Gallery, Italy

Frontispiece:
Nora Fok
Physalis Earrings 2006
Length 7.5 cm
Knitted dyed nylon with skeletonised
physalis shells
Photo: Frank Hills
Artist represented by Lesley Craze Gallery, London

col lect

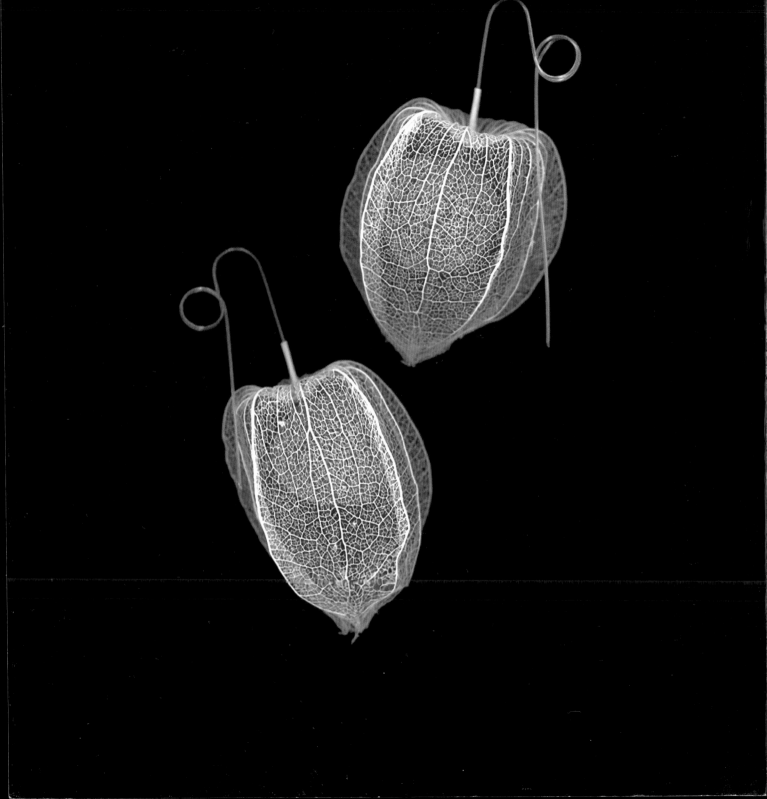

Contents

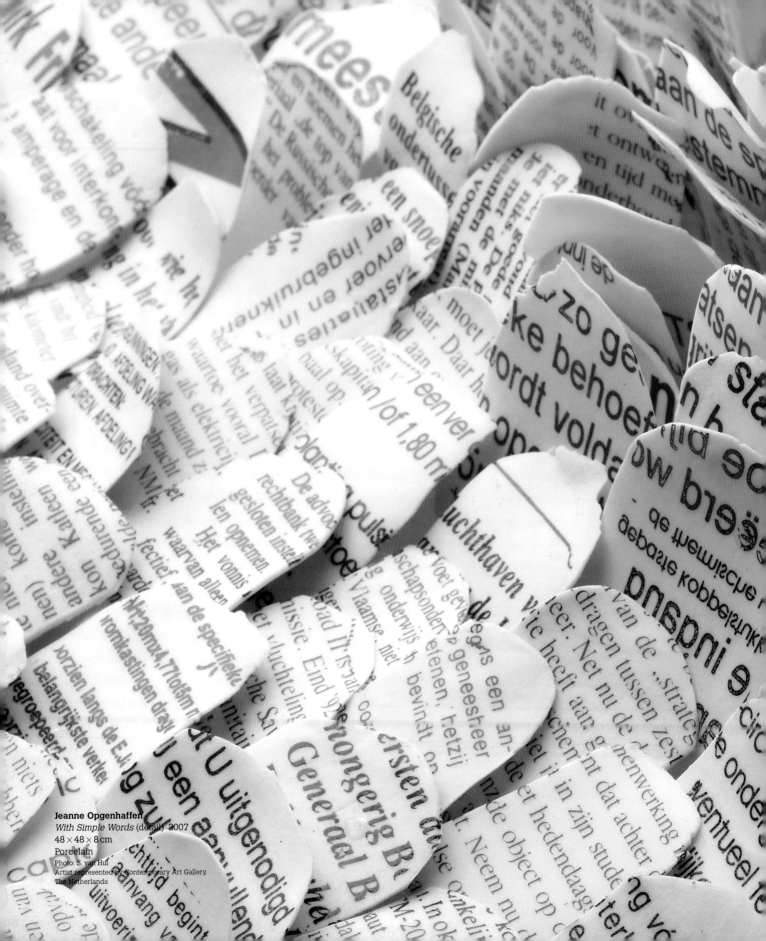

Jeanne Opgenhaffen
With Simple Words (detail) 2007
48 × 48 × 8 cm
Porcelain
Photo: S. van Hul
Artist represented by Contemporary Art Gallery,
The Netherlands

Essays

Forewords

This fifth year of Collect at the V&A is a good opportunity to recognise the achievements of the Crafts Council in creating a world-class event that has brought the best of international contemporary craft and the most energetic and innovative galleries from around the world to Britain.

The V&A has been glad to support the launch and early years of Collect and is working with the Crafts Council on other projects to raise the profile of contemporary craft.

Mark Jones, Director, V&A

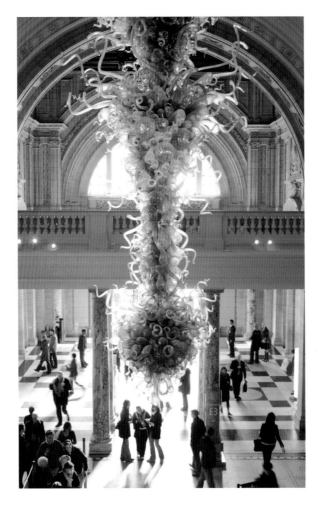

Dale Chihuly
V&A Rotunda Chandelier 2001
Height 8.1m
Blown glass and steel
Photo: V&A Images/Victoria and Albert Museum

Since last year's Collect we have been reviewing how we work at the Crafts Council, as the national development agency for contemporary crafts. It has been a fascinating process especially as we have been exploring our own contemporary role in the context of the rapidly changing world around us. A complex world where borders continue to shrink; competition and consumer choice to expand and, provoked by the electronic and digital possibilities now open to us, the pace and pressures of life to accelerate.

This last year we have done a great deal of journeying to remote rural areas and to our major cities. We have met, listened to and discussed with colleagues who are part of the country's thriving creative industries. We have met makers, educators, curators, gallery owners and collectors. The hallmark of our travels has been creativity, innovation, skill and passion; these qualities abound. The growing awareness and willingness to work together across traditional boundaries is clear. It is clear too, that the sector is already making a significant contribution to the economic and creative health of the country, but, it continues to need support and encouragement. Although there are now more makers making, they are not making more money as individuals. Making a living is still hard. As a result of our diverse conversations, we feel that our strategic vision about positioning the UK as the global centre for the making, seeing and collecting of contemporary craft is the essence of what we do at the Crafts Council. Collect exemplifies this vision.

It gives me great pleasure to introduce to you this year's Collect catalogue, which is not only a beautiful book but also a valuable guide and reference work to contemporary decorative arts today. The introductory articles look at some of the choices behind both private and public collecting. Emma Crichton-Miller reveals the rationale of the collecting and commissioning trail-blazer Sarah Griffin. Curator Andrew Renton discloses the philosophy underlying the impressive displays at National Museum Wales. We have comment from the esteemed designer and furniture maker John Makepeace, who casts a critical eye over where we are with contemporary furniture and from agent provocateur, Garth Clark, president of the Garth Clark Gallery, who opens the discussion of where Craft fits in the broader cultural arena.

Yes, creativity, innovation, brilliance and passion abound, and it is the inspiring philanthropic viewpoint of a gallery owner or patron that is so crucial to shaping the successful course of an artist's career. We hope you will share with us the inspiration that comes from your experience at Collect – and you will be tempted to start or add to your own collection.

Joanna Foster CBE, Chair, Crafts Council

Introduction
Rosy Greenlees

Welcome to Collect 2008, where a record number of ten new exhibitors are taking stands this year. We are extremely proud to be presenting this fresh injection of carefully chosen artists to the event: Craftscotland presents internationally recognised artists against a selection of the new generation in Scotland; the Danish Galleri Montan shows artists with a solid background in the craftsmanship of silversmithing – with a contemporary edge; The Glassery from Sweden has four provocative Nordic glass artists; Konsthantverkarna, the oldest and biggest co-operative of craftsmen in Sweden, is showing a mixed-discipline selection designed to highlight dramatic contrasts within their work; Yufuku from Japan have chosen work that embraces tradition but demonstrates a cutting-edge aesthetic, and the Guil-Guem Metal Arts Research Centre from Korea displays a solo presentation for Jung-Sil Hong, a master of metal inlay devoted to carrying forward the tradition of this ancient craft; West Dean Tapestry Studio in West Sussex is creating new works from this niche area, including three artists who will work collaboratively on individual pieces inspired by their recent contemporary re-creation of the medieval Hunt of the Unicorn series of seven tapestries that hang in the Cloisters at the Metropolitan Museum of Art in New York for Stirling Castle. Finally, significant new presentations in art jewellery include Galerie Rob Koudijs – a recently opened gallery in The Netherlands; a very focused selection from Galerie Sofie Lachaert from Belgium and UK-based Cockpit Arts, presenting some of the best of British jewellery from their organisation.

Collect 2004
Photo: John Chase

Collect 2005
Photo: John Chase

There are also interesting developments with long-standing exhibitors. Clare Beck at Adrian Sassoon presents a focus on *Monumental Pots* by four artists who already have a reputation in this area. This work is usually made for commission and therefore rarely seen by a large audience and indeed very infrequently made speculatively for purchase. And The Gallery, Ruthin Craft Centre, have expanded their display to include artists who have either shown, are currently touring or will play a major part in the new centre's programme to celebrate redevelopment of their building due to open in Summer 2008.

This year at Collect there promises to be a very exciting opportunity to see new work and galleries as well as to visit some of our regular exhibitors. But it is also an important year because it will be our final year of Collect at the V&A. Over the course of our five-year agreement with the V&A Collect has been a huge success both in attracting international and UK exhibitors, visitors and collectors. When the fair was launched in 2004 we had three key objectives. Firstly, we wanted to raise the profile of contemporary craft within the UK and internationally. Feedback from exhibitors and the wider sector is that Collect offers an increase in profile for them. In the words of Alternatives Gallery, Italy: 'Collect is one of the best opportunities for galleries and artists to source collectors and curators from all over the world.' Collect has become a byword for quality. Our high standard has been maintained by the selection panel, which makes the difficult decision of determining the exhibitors each year. We have been able to build on the event by establishing an education programme that stimulates debate about contemporary craft. Collection, our series of satellite activities, has been very successful in both providing context and enabling other organisations to participate in the overall event. Such activities raise the profile of craft and encourage visitors to develop their understanding of the practice. This year we are focusing on London and Edinburgh to coincide with the Jerwood Applied Arts Prize 2007: Jewellery (12 October 2007 – 2 March 2008) at the National Museums of Scotland.

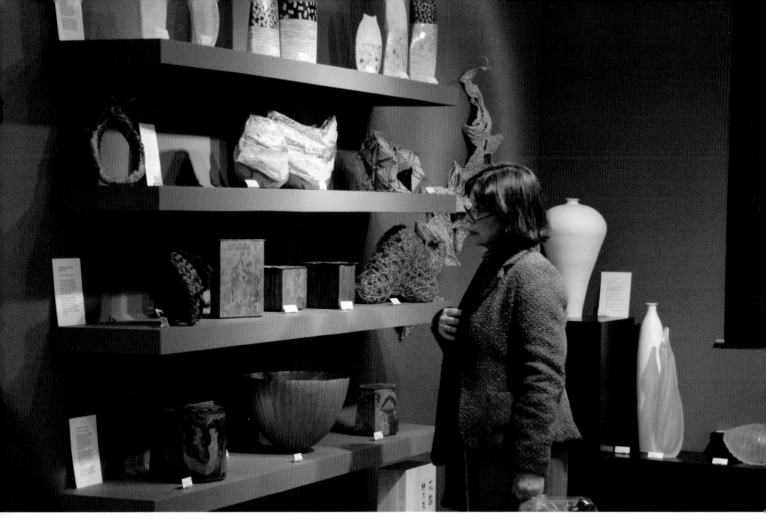

Collect 2006
Photo: Paul Endersby

Our second objective was to establish Collect as a unique promotional and professional selling event. The feedback has been that Collect is an important and indeed has become an essential part of the cultural calendar. We have been successful in attracting exhibitors from across the world, and each year we have strengthened the representation, from the 10 countries showing in 2004 to the 15 that appear in 2008. Increasingly Collect has become recognised for the additional benefits of participating and visiting Collect beyond the sales. These are the opportunities to exhibit work, gain exposure, make contacts and new clients and view a survey of international contemporary craft.

Finally, we wanted to develop the collector's market for quality work within the UK. Collect has generated over a £1 million's worth of sales each year at close of show, and the high standard of the event has attracted buyers not only from the UK but also from further afield, from Europe and the USA. The strength of jewellery has been particularly important, resulting last year in significant sales to private and public collections in Switzerland and the United States. We want to encourage both private and public collecting, and Collect has also drawn curators from across the UK, resulting in some major acquisitions for galleries and museums.

Last year we undertook a survey on Collect and found that it is recognised as a key event for the crafts, providing opportunities to sell work and support for the sector as a whole. The response also indicated that there is potential for the event to grow

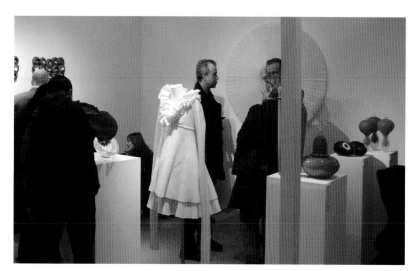

Collect 2007
Photo: Paul Endersby

in international representation and status. So, we are developing our plans for Collect, building on the foundations of five years at the V&A.

I should like to thank the V&A for its commitment and support for Collect. Of our other collaborations, I hope you will take the opportunity to see *Out of the Ordinary: Spectacular Craft* – a V&A and Crafts Council exhibition (ends February 2008), and the first in a series of landmark triennial exhibitions – and will pay a visit to our *New Faces 08* showcases at the V&A shop. I am also proud to announce jeweller Dorothy Hogg MBE as the first to take up the Museum Residency programme based in the Sackler Centre for arts education at the V&A, which enables makers to take time out of their practice for research and personal development, using the V&A and Crafts Council's collections for inspiration (starts March 2008).

I should also like to thank Arts Council England for their support of the Crafts Council and all our other funders and patrons. My thanks go to the Collect selection committee: David Barrie, Director of the Art Fund; Emma Crichton-Miller, journalist and writer; Alun Graves curator in the Department of Sculpture, Metalwork, Ceramics and Glass at the V&A; Andrew Renton, Head of Applied Arts at the National Museum Wales; Jorunn Veiteberg, PhD, Professor of Craft Theory at Kunsthøgskolen i Bergen (Bergen National Academy of the Arts, Norway) and editor of the Norwegian arts-and-craft magazine *Kunsthåndverk*.

Each year the participating galleries and exhibitors make a sterling effort to maintain the standards of Collect and create such a great event and atmosphere. Our thanks go to all of them and to the Crafts Council staff who have contributed to the success of Collect 2008.

Rosy Greenlees, Executive Director, Crafts Council

Uncertain Beginnings, New Ambitions
Craft collecting at Amgueddfa Cymru –
National Museum Wales
Andrew Renton

Walter Keeler
Serving Bowl 2004
13.9 × 22.6 × 17.3 cm
Creamware, 'inkwash' glaze
Photo: National Museum Wales

In January 1924 the young National Museum Wales, founded in 1907, acquired its first contemporary craft work, a slipware vase by Bernard Leach. Described by its maker as 'the best pot of the same ware which I have made in England', it was purchased direct from the artist under the auspices of Dr W. E. Hoyle, Leach's uncle and the National Museum's founding director. This personal relationship promised much – while in Japan, Leach had previously sent to the Museum a Japanese tea-ceremony collection and debated the aesthetics of museum display with his uncle – but it proved a false dawn. Following Hoyle's premature retirement in 1924, subsequent craft acquisitions were of mixed quality and sporadic at best, separated at times by years and even decades. By 1993 the Museum's craft collection comprised a mere 55 works representing 21 artists. In 1974 six fine pots by Hans Coper were purchased, as were seven more by Richard Batterham and interesting early jewellery by Wendy Ramshaw, Helga Zahn and Susanna Heron, but this outbreak of enthusiasm was as short-lived as it was admirable.

It is indicative of the Museum's priorities that until 1994 Walter Keeler, long established as the pre-eminent ceramicist working in Wales, was not represented at all in its art collections but by a solitary bowl acquired (laudably, of course) for the Museum's Schools Service handling collection to travel around the schools of Wales. This, indeed, could claim to have been the Museum's only systematic collection of contemporary craft, brought together to illustrate a range of ceramic techniques and styles, and including the work of Katherine Pleydell-Bouverie, Helen Pincombe, James Tower and others. In 1993 the loss of works by Lucie Rie forced the transfer to the art collections of the best pieces and prompted a more strategic approach to the collecting of craft.

Bruno Romanelli
Reflect I 2005
10.2 × 34 × 33.9 cm
Cast glass, mirrored base
Photo: National Museum Wales

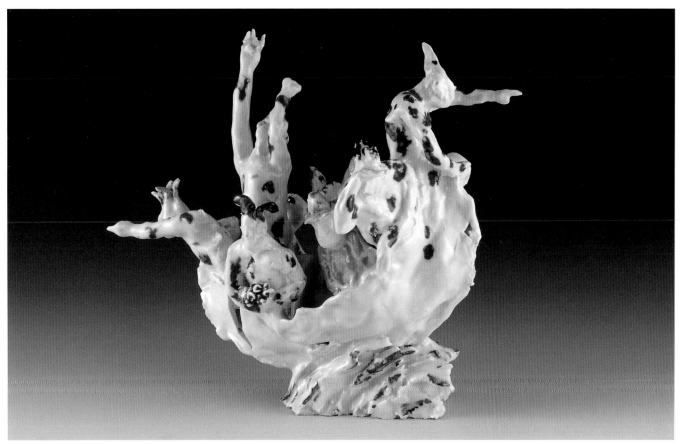

Michael Flynn
Ship of Fools VII 1999
26.2 × 31.1 × 13.9 cm
Porcelain
Photo: National Museum Wales

In the mid-1990s, therefore, work was acquired directly from 16 artists to illustrate the richness of ceramics practice throughout Wales. Some – Walter Keeler, John Ward, Phil Rogers – were well-established; some – like Cardiff-based Morgen Hall and Swansea's Christine Jones – of a younger generation; others – Mick Casson, for example, and Geoffrey Swindell – associated with the respected ceramics department at Cardiff School of Art and Design.

By now the potential and the limitations of the collection were better understood, and in 2005 a collecting strategy defined its purposes more clearly. Chief among these is the development of a collection with a distinctive Welsh personality. Work by Michael Flynn, Claire Curneen and Catrin Howell has been acquired to reflect the figurative tradition that flourishes in Wales, as has new work by Walter Keeler, but it is a significant challenge to the Museum to keep pace with the abundance of Welsh talent, particularly in ceramics. Nonetheless, the Museum always seeks to promote Welsh cultural achievement in an international context by acquiring work by influential artists from the rest of Britain and beyond, though the latter is still largely an aspiration. Recent acquisitions therefore include the witty polemic of Carol McNicoll's *Post-Colonial Images of Humanity* (2001), standing and sitting figures by Mo Jupp (1995, 2003) that complement figurative work from Wales and the emotionally charged child's sarcophagus from Julian Stair's display at Collect 2004. Somewhat unusually, the Museum also acquires retrospectively work by key historic figures. Effectively limited to ceramics, this helps draw together the rather disparate early acquisitions and gives a proper context to contemporary work. Thus, fabulous slipware by Cardiff-born Clive Bowen now partners fine early pots by Michael Cardew.

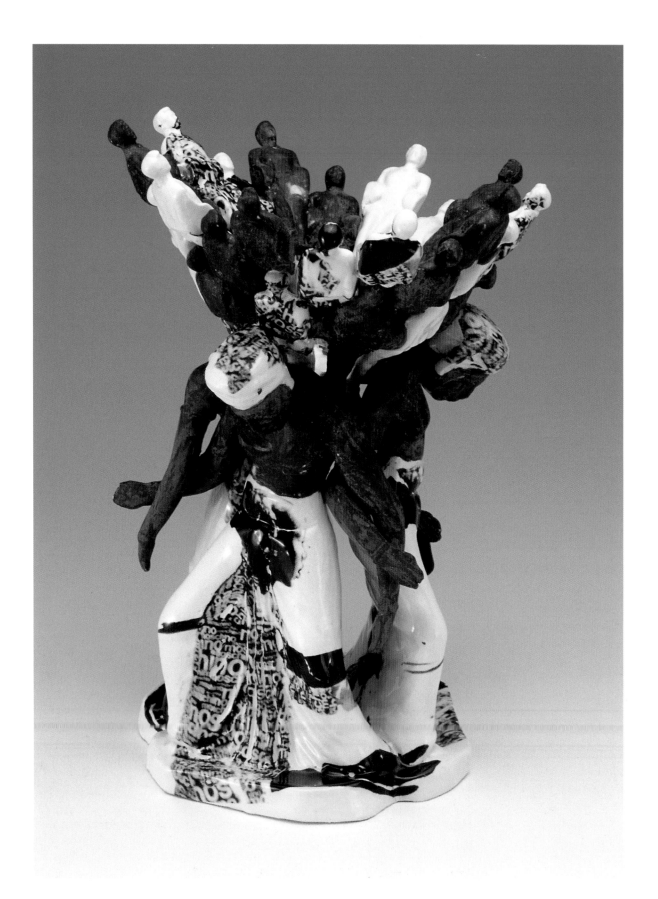

Carol McNicoll
*Post-Colonial Images of
Humanity* 2001
27.7 × 20.8 × 18.7 cm
Slip-cast earthenware
Photo: National Museum Wales

Pamela Rawnsley
Pair of Cwm Cwareli Vessels
2006
Left: 9 × 12.8 × 3.9 cm
Right: 9 × 12 × 3.9 cm
Sterling silver, 18-carat gold
Photo: National Museum Wales
Funded in memory of Jack and Dolci
Josephson by their daughter Rita Plowman
through the Derek Williams Trust

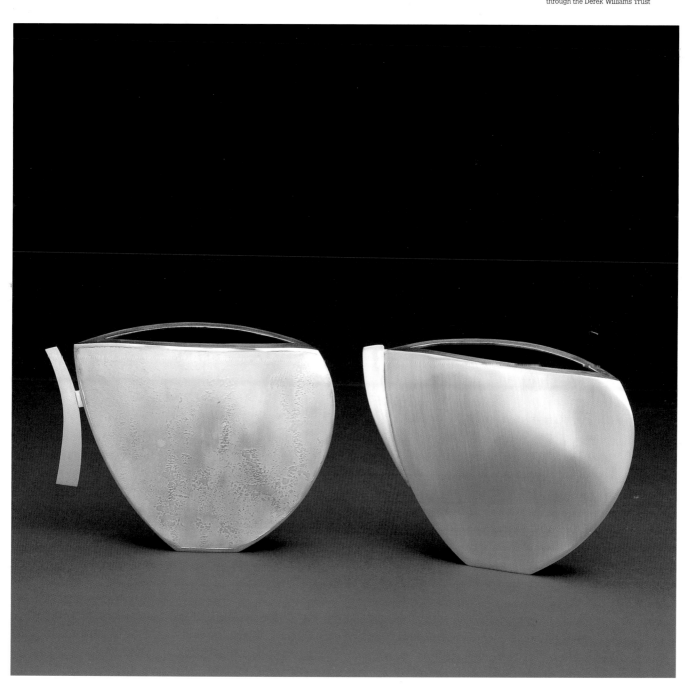

Angela Cork
Shift Vase 2006
Height 25.6 cm
Sterling silver
P&O Makower Trust Collection, on loan
to National Museum Wales
Photo: Angela Cork

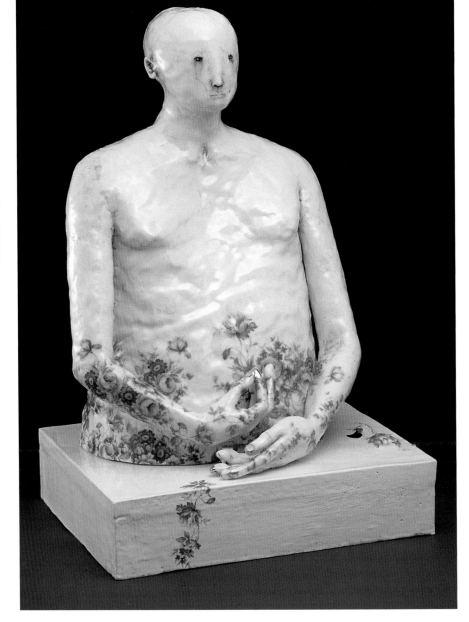

Claire Curneen
Blue Series 2002
47.5 × 33 × 26.7 cm
Porcelain, earthenware, transfer
prints, gold lustre
Photo: National Museum Wales

Edmund de Waal
Porcelain Wall in the *Arcanum*
exhibition, National Museum
Cardiff, 2005
As installed, height 347 cm,
width 100 cm
Porcelain
Purchased with assistance from
the Colwinston Charitable Trust, the
Derek Williams Trust and The Art Fund
Photo: National Museum Wales /
Robert Teed

We are also determined to look beyond a narrow focus on ceramics, to reflect other areas of strength in the historic applied-art collections and to cover ground not so accessible to other public collections in Wales (primarily, the ceramics collection in the School of Art at Aberystwyth). Initially, this means glass and metalwork, with aspirations in future to strengthen a modest jewellery collection and to consider furniture and textiles when resources allow. *Glass* by Colin Reid (2003, a work inspired by corroded stonework at Gloucester Cathedral) and Bruno Romanelli (*Reflect I*, 2005) has been acquired, as has silver by Hiroshi Suzuki (*M-Fire II*, 2005) and Wales-based Pamela Rawnsley (four pieces, 2004–6). This new direction was given a significant boost in 2007, with the transfer on loan to the Museum of the P&O Makower Trust's collection of contemporary silver that since 1993 had been commissioned for loan to the Crafts Council and that will continue to grow in Cardiff.

We hope, too, to build a distinctive and dynamic collection that sits organically within the art collections as a whole by working directly with artists, encouraging them to engage with the Museum's existing collections and seek in them inspiration for new work. Before making the *Blue Series* torso figure (2002), Claire Curneen studied portraits by Gwen John and Welsh porcelain, which led her to use gold for the first time. In 2005 Edmund de Waal's fascination with the Museum's huge collection of eighteenth-century continental porcelain inspired a new body of work, and his display of new and old together in the exhibition *Arcanum*.

Other relationships important to the growth of the collection include that with the Cardiff-based Derek Williams Trust. Since 1993 the Trust has worked with the Museum to promote the appreciation of art made after 1900, placing its own collection on loan at the Museum and part-funding many of the Museum's own purchases. The Trust's growing interest in craft has enabled the Museum not only to buy works, most notably silver, but also to display objects that it could not acquire itself, such as a magnificent pair of tall porcelain jars by Edmund de Waal, from his 2004 exhibition at the New Art Centre, Roche Court, and most recently an important vase made in Vienna by Lucie Rie.

What this all describes is a collection that from uncertain beginnings is finding a sense of purpose and ambition, ambition that inevitably outstrips available resources but that will, it is hoped, raise the profile of craft in Wales and allow the Museum to engage more dynamically with an increasingly vibrant national and international craft community.

Andrew Renton, Head of Applied Art, Amgueddfa Cymru – National Museum Wales

'How you live with beautiful things'
Emma Crichton-Miller interviews Sarah Griffin

Julian Stair
Maquette 2006
Model with various clays
Photo: Julian Stair

I can identify the house. It is covered in scaffolding. There is no proper bell and the ground outside has been pummelled by builders and removal men carrying to and fro. Inside, however, everything is spacious and filled with light. Although Sarah Griffin has only recently moved into her new house, already there are clusters of beautiful objects in different rooms. A row of Inger Rokkjaer pots, deep blues and greens, some ochre and saffron yellow, are arranged on a mantelpiece; a poised arrangement of Julian Stair teapot and tea bowl on a plinth stands on a shelf in the dining room; one bathroom wall offers a display of white pots; three majestic celadon vases by Felicity Aylieff rise up from a shelf in the kitchen.

As Sarah explains, the whole process of unpacking her collection, trying out the pieces in different rooms, arranging and rearranging them, has been extremely beneficial: 'It's been a really good editing process. Not that the things I collected early on are not beautiful, but they were a lot more affordable and the artists themselves were a lot younger – it was all to do with the time of my life and my budget, and you can make mistakes.'

Sarah Griffin is a leading member of a new generation of collectors of fine craft. Not only has she gathered together an impressive and distinctive collection of contemporary ceramics, but she has also more recently begun to commission a range of artists across different media to create pieces specifically for her new home. Edmund de Waal has re-created his magnificent piece, *Porcelain Room*, first displayed in the Geffrye Museum 2001–2, for an enclosed passageway between the hall and the garden. Griffin has had purpose built a cavity in an upstairs corridor ceiling to hold his *Attic*. On one of two dramatic landing spaces besides the stairs, Julian Stair is creating an installation, while Deborah Thomas has conceived a magical, flamboyant chandelier for the formal dining room. Griffin has commissioned Charlotte Hodes, winner of the 2006 Jerwood Drawing Prize, to create a dinner service and soon, when the landscape architects have left, seats designed by Alison Crowther will grace the garden.

Griffin has not been collecting long, but already she has won admiration for her informed enthusiasm, persistence and self-discipline: 'It's nice to think of the whole collection and how things work altogether, not just to buy random things and hope they slot in. I think about things in groups, and I did only have white pots up until about five years ago. I needed to break out of that!'

Griffin started collecting contemporary craft by chance: 'The first thing I ever bought was a drawing of a dog by Nicola Hicks, which I bought when I was 18. I really wanted to collect art and contemporary art was my job. I spent years studying it, and I went to New York and worked at the Guggenheim Museum. But I came to hate that

Edmund de Waal
Porcelain Wall 2007
Porcelain
Photo: Hélène Binet

Sarah Griffin's collection of white pots
Various artists
Photo: Tina Whitlow

contemporary-art world in New York. And then my mother gave me these two Edmund de Waal pots, and I just loved them. They seemed to represent the opposite of everything that I disliked in New York. And so when we moved back to London about a year later, that was it. I just went to the Crafts Council Shop at the V&A practically every day.

'When I started collecting, people like Julian Stair and Joanna Constantinides were coming through, and then there was this exhibition at the V&A, *The White Exhibition*, that really ignited my interest. In the meantime my husband started to buy me jewellery by Gerda Flöckinger. I love her work. She has such a wonderful approach to her jewellery. And we went rushing off to degree shows. Egg [the shop in Kinnerton Street] was a really great resource. I thought their aesthetic was wonderful. But it was very slow in the beginning and I had definitely to find my way about a bit.'

The selling exhibitions curated by Janice Blackburn at Sotheby's were a big influence: 'The first one that she did, there was this table by Jim Partridge with place settings by Julian and silver by somebody else – it was just layers and layers and layers of how you could live, with every aspect of your life handmade.'

Through her collecting, Griffin has got to know the artists: 'It was really Edmund and Julian first. Julian said something to me a while ago, "You know, every time I've done something quite new for me or I've gone in a new direction, you've picked up on that and you've bought it." That is an enormous part of the pleasure for me.'

Commissioning was the obvious next step. 'It just seemed a natural step on from really enjoying their work and knowing them. I am very conscious that I haven't collected anybody who is dead, apart from Joanna Constantinides, and maybe a few David Leach tea cups. With Edmund it was also that he was just developing this really exciting work, work made specifically for a domestic interior rather than for a gallery, and suddenly we had space for it. It's really exciting to be part of that.'

Another motive was Griffin's awareness of the limitations for the artist of the gallery system: 'There is rarely the opportunity to go out on a limb – they can't financially afford to do it sometimes and then logistically what are they going to do with that massive thing they have made? So you are enabling them to do something more with their work. It's really not so much getting what you want.'

It has, however, largely been a happy experience: 'I have never felt that any of them would take this as an opportunity to make something unexpected or bizarre. It was always a close partnership. I felt really confident about what they did and have never said, "Well, I really think the pots that go there should be this colour." I would be very

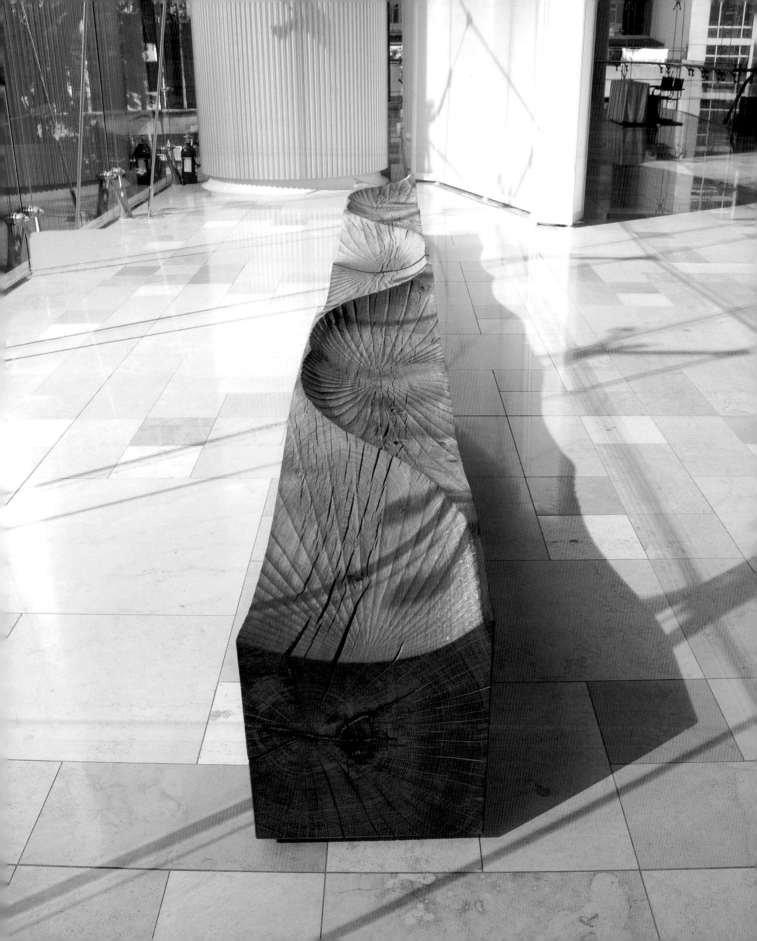

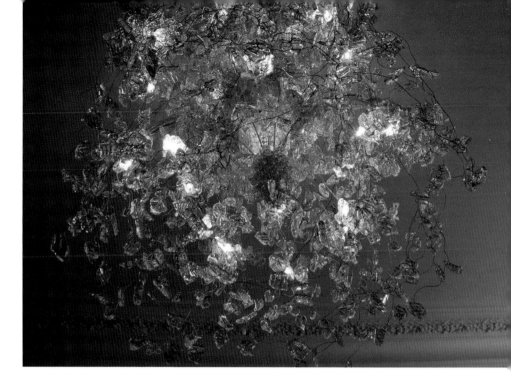

Deborah Thomas
*Broken glass fragments, nickel
wire and steel* 2007
100 × 10 × 100 cm
Broken glass, wire
Photo: Tina Whitlow

disappointed if someone made me what they thought I wanted, in a very literal way. So it's a very dignified relationship to have with an artist.'

Griffin also feels strongly that the work looks best in a home: 'That is one of my frustrations with seeing craft. You either see it in gallery spaces – that are very cold, and people tend just to look at the individual object by itself – or it's the kind of Craft Shop brown-mug situation.'

The notion of function, however attenuated, is also very important to her: 'It's not that you have to use everything, but that's what its root is. That gives it an identity that is very strong. It releases it from being contemporary art. It puts it in a whole different arena. And then you can build up to something like *Porcelain Room*. And that's one of the things that I find so amazing about it, because if you wanted to you could have a cup of tea out of one of those pots. Its intentions and origins are very clear. But it's also sculpture.'

In many ways Griffin is delighted to discover herself to be part of a long tradition of appreciating the decorative arts: 'I spent every summer between the ages of eight and twelve going to Blenheim Palace, Waddesdon Manor and other stately homes. It was what my mother used to do with us. And I would spend hours in those porcelain rooms. I thought they were absolutely amazing. So I thought it was brilliant when Edmund saw that room and said that it was a *Wunderkammer*. It was really coming full circle.'

For the future, Griffin is keen to encourage others to commission and collect: 'I really want the V&A to have big, important, representative pieces by some of these people. They need to be in other national collections. They need to be in other people's homes too, so anything I can do to show people what it's like. It's not about the trophy object, it is about how you live with beautiful things.'

An interview by Emma Crichton-Miller, freelance journalist

Alison Crowther
Kissing Bench 2006
50 × 600 × 45 cm
Carved unseasoned oak
Photo: Swire Properties Ltd

Distinctive Markers of Our Time
John Makepeace OBE

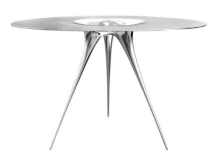

Ross Lovegrove
Liquid Trilobal Table 2007
Height 59 cm, width 72 cm
Milled mirror, polished
aluminium
Photo: John Ross

Fortuitous events can shape our lives. A visit to the home and workshop of Hugh Burkett when I was 11 aroused a passion in me for furniture-making that has grown to be a vital part of my life. Perhaps the reason for this lies in the variety of challenges furniture making involves and how ones approach changes both through our own personal development and as new possibilities arise. Certainly surviving as a furniture designer and craftsman makes demands on many aspects of our abilities – creative, practical, social, commercial and organisational – making for an extraordinarily fulfilling pattern to life. Inventing forms to express ourselves requires a degree of fluency in ever-changing technology as well as curiosity and persistent experimentation. Nature magnificently demonstrates great beauty in the way it evolves to meet circumstances with both economy and distinctive 'appropriateness'. That it does this without repeating itself blows my mind.

Our homes echo this infinite variety of adaptations to our practical, emotional and spiritual needs. Increasingly we are sensitive to the wider impact of our choices and how these resonate ethically. Creating a wholesome refuge is a continuous adventure that reflects our changing values and circumstances. Collect serves as a valuable stimulant on that journey.

The production of furniture has changed dramatically over recent decades. Only a few volume manufacturers survive in the UK – indeed Britain imports 90 per cent of its timber and timber products. In contrast, there has been a growing number of design- and quality-led batch producers for contract and retail sale. Then there are the hundreds of workshops designing and making furniture to commission to a wide variety of creative content, quality and price. Some employ twenty or more craftsmen, others are single-handed, both fulfil commissions ranging from interiors in Moscow or New York to individual items for local customers. The equivalent in ceramics, glass, silver and jewellery, effectively promoted by the Crafts Council, is to be found in galleries, and is therefore well represented at Collect.

However, many galleries shy away from exhibiting larger items in favour of the smaller, faster-selling works. This seems particularly unfortunate. Although the smallest galleries may not have space, those with more room could benefit from a greater variety of scale in their exhibitions. Not only would this demonstrate a more complete range of lifestyle options but also broaden consumer choice. As Britain has such a large number of furniture designer-makers, often working in isolation and without a shop-window, there are opportunities for galleries to benefit from the growth in the market for commissioned items of a relatively high value. Even with a modest mark-up, there is scope for galleries and makers to benefit while increasing their client base. With a simple contract, the gallery needs do little more than regularly exhibit an exceptional example of a maker's

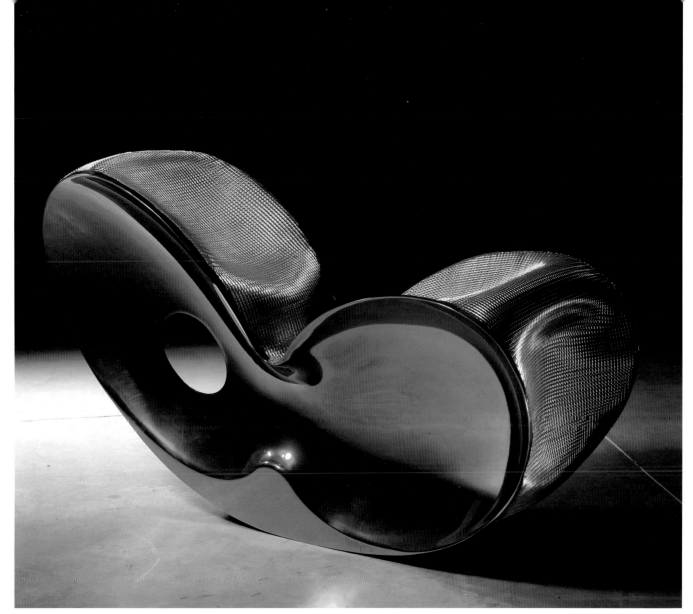

Ron Arad Associates
Blo-Void 3 2004
127 × 58 × 82 cm
Woven polished aluminium
and polished inflated green
aluminium
Photo: Tom Vack

work with an accompanying folio of other works then provide introductions
and advise the maker of interested customers. Any contract should stipulate the
nature and duration of the agreement and be regarded as the basis for active
promotion.

The growth in the commissioning of furniture enables customers to find what
they want far more effectively. The role of the 'patron' is a combination of rebel
and leader: rebel in that conventional answers are rejected in anticipation of
a better solution; leader in the way it helps identify shared objectives. Perhaps,
unexpectedly, these may be best expressed in verbs to describe the activities that
the commissioned object is required to support. This has the effect of opening up
the potential answers in a way that nouns restrict: for example, the word 'desk'
may bring to mind a mental picture, probably of an existing object. This rigorous
approach is a good exercise in displacing preconceptions enabling a clearer
expression of what is essential.

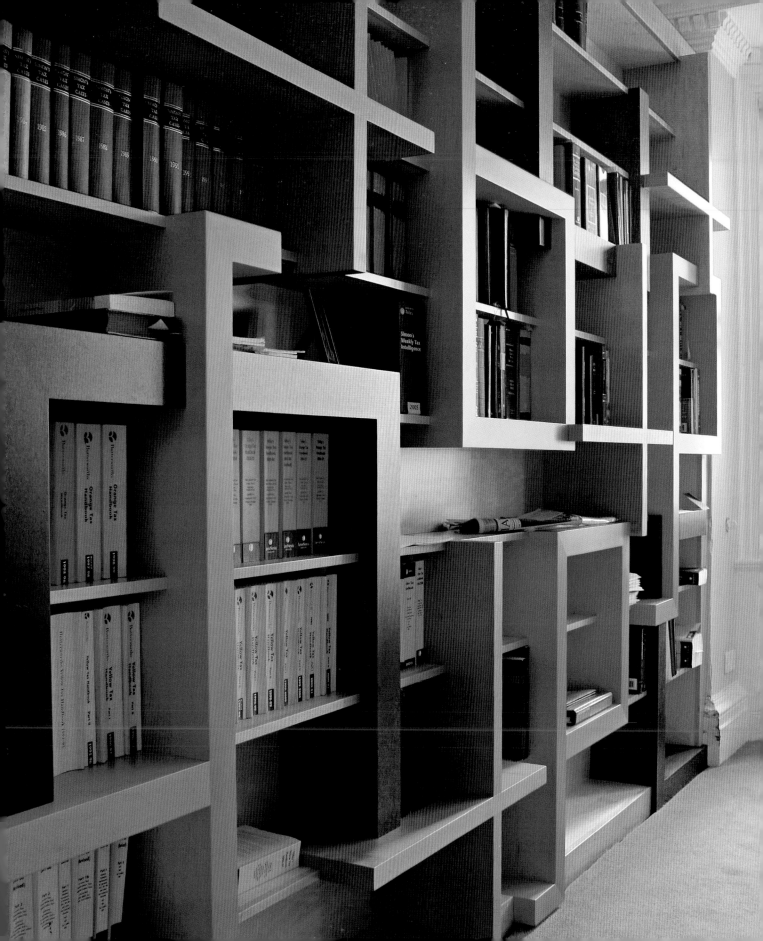

opposite:
Fred Baier
Bookcase 2007
Maple and board products
Photo: Phil Grey

In addition to Collect, there are many national and regional museum collections, galleries, exhibitions, magazine and newspaper articles that feature the work of designer-craftsmen. Choosing a maker is best done knowing several in order to find someone whose work has a strong appeal. Once identified, a meeting will help to establish whether the relationship is likely to be fruitful and explore questions about timescale and cost. A studio visit can be revealing; conversely designers like to see the proposed location to get a better feel for the project. It is worth remembering that patronage is an adventure that calls for a degree of courage if it is to generate distinctive results. Choosing an artist well and giving them opportunity and encouragement is hugely motivating. The results are inclined to exceed any reasonable expectations.

Only in recent years have I discovered for myself the thrill of commissioning in a small way, not furniture but iron, stainless-steel, silver and fibre pieces. It may be just one person's work that truly moves you with its fresh integrity, someone fluent with their materials and processes and able to bring a new and exciting insight to their potential. One of the most rewarding aspects of commissioning is helping to enable that potential, allowing it to be explored and developed. It is an aesthetic exploration, a partnership between patron and artist, that can lead to the creation of objects that will come to make their unique mark on the culture of our times.

The possibilities are legion and range the gamut of human character, from the traditional to the innovative. The choice of maker, the materials, the available technology and the courage of the patron determine the possibilities. Developments in form and structure take place all the time as our understanding of material science grows. While this is most dynamic with new, emerging materials, the science of the relationship between existing materials reveals how they can be combined so

Gareth Neal
Reception Desk (concept in progress)
350 × 100 × 80 cm
Rendering for walnut
Photo/rendering: Gareth Neal

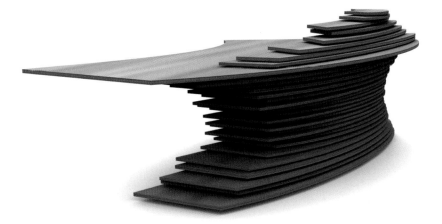

that the strengths of one can be used to overcome specific weaknesses in another to bring out the best of both with the greatest economy and an unprecedented lightness and strength. All too familiar is the failure of antique chairs in the levels of varying humidity, from the drying effect of central heating in winter to the wet conditions of a damp summer. Wooden joints do not cope well with such stresses, and heavier components compound the problem. An extraordinary improvement in performance is possible by using steel and resin to join timber. With lighter timber sections, the whole structure becomes more resilient and therefore more enduring.

The long history of making furniture out of natural materials has resulted in a well-established battery of techniques available to the manufacturer, as well as many more that demand high levels of individual craftsmanship. These are integral to the vocabulary available to those making one-of-a-kind pieces to commission. By way of contrast, a new breed of designer is focusing on materials that are largely new

John Makepeace
Vault 2005
72 × 150 × 290 cm
English oak planted at Longleat
in 1760 and felled 1980
Photo: Mike Murless

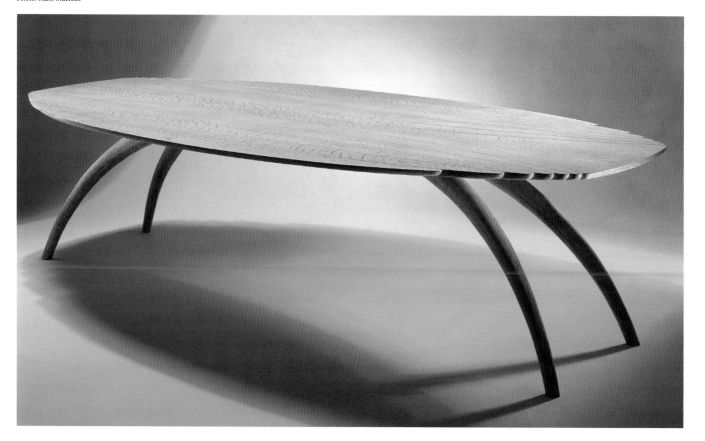

Wales & Wales
Wall-hung chest of drawers
2005
46 × 27.5 × 27.5 cm
Bog oak, gold inlay, paint
Photo: Leigh Simpson

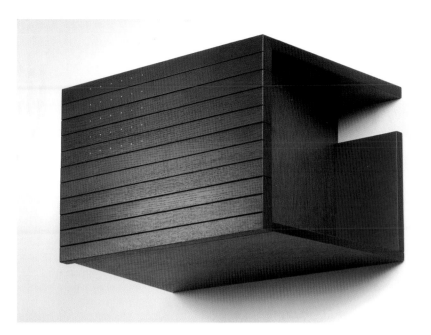

to furniture-making. The properties of these new materials demand quite different structures and processes. At best, this can result in highly innovative, expressive and functional forms. Resolving how to create a product of this type calls for intense development and substantial capital, and recouping the costs will often require the manufacture and sale of a series. Such items appeal especially to some collectors through their blend of cutting-edge design and technology combined with their limited availability as distinctive markers of their time. A cluster of designers working in this vein has gathered around London. Their proximity in a highly creative and mutually supportive environment is indicative of the energy that such groupings can generate. Their collaboration with industries pioneering new manufacturing technologies or transferring existing ones to new applications opens new avenues for the future.

However, timber retains its beguiling, timeless appeal. Despite the gulf between timber-growing and the consumer, environmental issues increasingly favour the use of indigenous and sustainable materials. Available in limited quantities, these are often sufficient for the scale required by designer-makers. Utilising them encourages landowners to plant and manage broad-leaved woodlands. The decline of 'home-grown' timber merchants leaves the initiative with makers to liaise directly with local growers rather than succumb to high-pressure marketing by importers.

The internet has become a valuable forum for designer-makers at a basic level. The more esoteric discussions tend to take place as a result of shared exposure to inspirational ideas, proving a catalyst for individual and group collaboration and development. Based on the principle that education and inspiration drive innovation, in May 2009, the V&A is planning a biennial symposium for professional furniture designer-makers. In addition to the opportunity to exchange ideas and information, papers by an international line-up of speakers will address topics including the scope for working more closely with galleries.

John Makepeace OBE, designer and furniture maker

Separated at Birth
Garth Clark

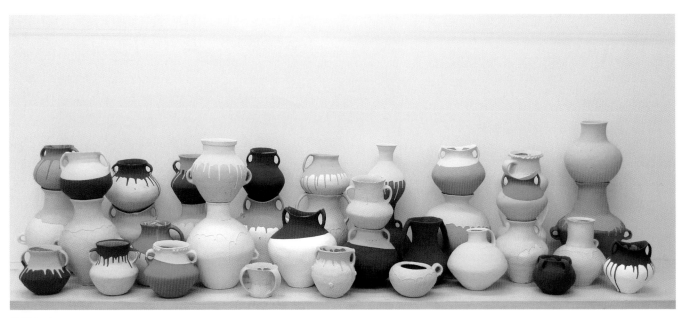

Ai Weiwei
Colored Vases (39 pieces) 2006
Various sizes, height c. 9–31 cm
Pottery, 3500–5000 BC,
Industrial household paint
Photo: Galerie Urs Meile, Beijing–Lucerne

When visitors attend Collect, they will be looking at two parallel but distinct movements, Craft and Applied Art, similar enough to be confused for one another, but actually quite different. To add to the confusion, the latter has tended to be presented under the umbrella of Craft, and many of its practitioners are refugees from Craft, young graduates of its educational programmes and heretics driven from the handmade fold. But it does not belong – only included there as a marriage of convenience.

The Reform Movement spawned more than just the Arts and Crafts. It gave birth to twins, not identical, but twins none the less. Craft and Applied Art arrived at the same time, around 1850, delivered from the same parent. Both grappled with materials and processes to create objects for home use and decoration. Both were motivated to action by witnessing industry's debasement of domestic design. Separated at birth, they took different paths.

Craft decided to fight industry's philistinism by reviving craft traditions that were then in decline and on the brink of extinction. It was a quixotic fight, hand vs machine, and inevitably the crafts lost but not before the Arts and Crafts had a huge impact. Until World War I, Craft was a primary cultural player, dilettante as it was, impacting on fashion, home decoration, architecture even theatre and literature, and it participated in the shaping of nascent Modernism. Alas, when the Modernist regime came to power, it autocratically banished Craft to the margins. Craft dropped to secondary status and remains there today.

Applied Art chose to burrow from within and improve everyday life by changing the aesthetics of industry. It changed its name to Design in the modern era. Today Design is an unstoppable juggernaut with its superstars, like Marc Newson and Ron Arad,

manufacturing millions of affordable designs, while their limited editions, selling for as much as $1 million each, have successfully hijacked much of Craft's market for high-end furniture and decoration. Design's newly acquired clout and glamour was taken up a notch recently by Newson's show at Larry Gagosian's gallery in New York, the ultimate temple in this city for the commerce of art. It reportedly grossed $50 million, and when Gagosian was asked if this meant that Design was now art, he answered that Design was just fine as Design, and he saw no reason to 'elevate' its stature. (Compare that stance of self-confidence to Craft's fevered attempts to be seen as art.)

To add to this energy we now have an art movement emerging boldly from Design's fringe that has unapologetically adopted the Victorian title of Applied Art, which in its day meant 'applying art' to design and architecture. Its players are fully aware of the negative, anachronistic connotations this name produces in the museum world, some quarters of the fine arts and even in the crafts. In part, this is its appeal. It is subversively derogatory. In some ways it is like gay rights taking back the pejorative 'queer', as a declaration of pride. Applied Art has also been claimed by some as 'hybrid craft', which my partner Mark Del Vecchio described at the 2006 American Craft Council conference, 'Shaping the Future of Craft', as 'the last death grasp of craft's hand from the grave' in order to retain contemporary relevance. While Applied Art is a complex mixture of social criticism, design, decorative and fine art, and, yes, craft as well, the term 'hybrid' makes it sound like a product of genetic engineering.

Marek Cecula
In Dust Real 2005
70 × 30 × 28 cm
Royal Copenhagen Porcelain,
wood fire
Private Collection
Photo: Sebastian Zimmer

32

32

Barnaby Barford
*Oh please mummy can we
keep it?* 2006
Height 31 cm, width 42 cm
Found objects, porcelain,
enamel paint, painted wood
Private Collection, New York
Photo: Garth Clark Gallery, New York

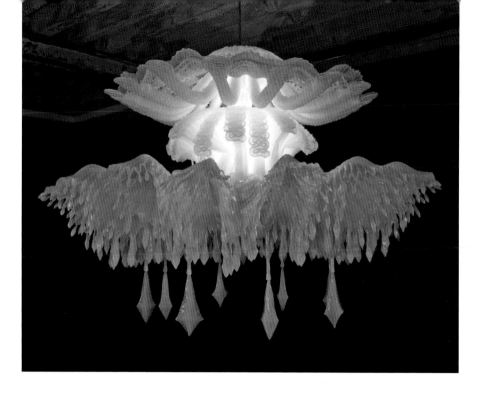

Tim Horn
Medusa 2006
Height 183 cm, diameter 259 cm
Silicone rubber, copper tubing,
lighting fixtures
Photo: Hosfelt Gallery, New York

Applied Art is not a mutant but the natural-born and legitimate child of the Reform Movement, its own entity. But it is sufficient generations down the line to have had its blood mixed with a number of other art disciplines, including conceptual art from the Arte Povera strain. Indeed, far from being a synonym for Craft, Applied Art functions better as an antonym. Yet, while many of its artists are clear in their purpose and their separation from Craft, critics and writers have been strangely circumspect in dealing with this movement. Even the Think Tank, a newly formed group of European art historians, theorists and writers engaged specifically in a 'discussion on the theory and practice of European applied arts', has neither separate definitions for Applied Art and Craft nor consensus from its membership about their use of these terms. This reluctance openly to declare independence from Craft is because Applied Art currently draws its resources from the Craft well. There is no Applied Art Council. If it becomes too strident and separatist, Applied Art risks having its funding cut off and losing access to the Craft network. So for the time being Applied Art is playing both sides – the Craft and Fine Art worlds – against the middle.

Applied Art takes little from Craft creatively speaking. Craft is hardly ever quoted without irony. Making, key to the definition of Craft, is not an important part of this journey, and Applied Art does not acknowledge the primacy of the hand. The applied artists are as happy to have others make their work as they are to clobber found ceramics or assemble ready-mades. Yes, occasionally, they do make works from scratch but usually without Craft's virtuosic, lifelong commitment to a single material. They are material polygamists who up-end the banal and the everyday to expose human dysfunction and consumerism's malfeasance. Applied Art is both urban and urbane. Being city-wise places it in the mainstream of contemporary society, rather than on its margins, where Craft lives. Craft still remains largely rural and rustic, remote from the metropolis, feeding off its preservationist mission and fuelled by nostalgia for cottage craft, the village smithy and country potter. Applied Art seeks its 'craft' through industrial technology in factories and science laboratories. Applied artists do employ the past but without nostalgia, getting their historical frisson from many sources but the favourite is the sophisticated, witty

Ai Weiwei
Tables at Right Angles 1998
Wood Tables, Qing Dynasty
(1644–1911)
175 × 126 × 174 cm
Photo: Galerie Urs Meile, Beijing–Lucerne

and foppish excesses of eighteenth-century decorative art ('palace craft' if you will) rather than the earnestness of the medieval craft guild or the imagined purity of the Sung potter.

Applied Art specialises in objects that celebrate uselessness while, paradoxically commenting on utility. Craft largely adheres to the functional. Craft sees its activity and its channeling of material as a spiritual mission. Applied Art is determinedly secular. Its conceptual bite comes from its irreverence, its cynical edge and acid satire. It is essentially conceptual art that results in an object. Barnaby Barford, the rage of the moment, is a good example. Aside from Grayson Perry, he is Britain's best-known ceramicist abroad. He is a media magnet, and major articles and features about his work have been appearing regularly in *Wallpaper*, *Arbitare*, *New York Times* and numerous other journals and newspapers. Barford neither owns nor uses a kiln. He does not glaze nor touch raw clay. He finds, slices, dices, assembles and paints existing ceramic objects, mainly figurines. Applied Art fits him like a glove but to claim him for the crafts would be ludicrous. While he does create functional objects, like the elegant olive plate he designed with Andre Klauser, these are manufactured and sold though outlets like the design store of the Museum of Modern Art in New York. He keeps these two activities – art and industrial design – separate, showing his one-of-a-kind pieces at the David Gill Galleries in London. Many in Applied Art do the same, serving dual masters, both shop and gallery, logical and synergistic dualism.

Applied Art in Europe and Britain is not new but it now seems to be shaping up into a cohesive, collective movement. Richard Slee (to whom Barford, and many of his generation, owe a large debt) has been on Applied Art's fringe his entire career, darting between Pop Art conceits and design ironies for decades. His recent enamelled metal tools are perfect additions to this dialogue, opulent and impotent, suggesting elaborate functions they are incapable of performing.

In America (slow to take up Applied Art's challenge) Marek Cecula has been the guiding shaman, influencing a generation of young artists with his perversely witty, industrial aesthetic. In his recent series *In Dust Real* he conflated two cultures with very different aesthetics, firing delicate thin-walled nineteenth-century European china in a Japanese anagama or tube kiln The warped assemblies of dishes that resulted are scorched orange and black by fire clouds and encrusted in ash. They are at once hauntingly beautiful and disturbing table-top memorials to some unnamed catastrophe. Not surprisingly, when we showed the work, members of the Holy Order of Woodfire Potters (HOOWOOP) were anything but amused by his usurping of their technique outside their largely traditional usage. Again, Applied Art and Craft are not on the same page.

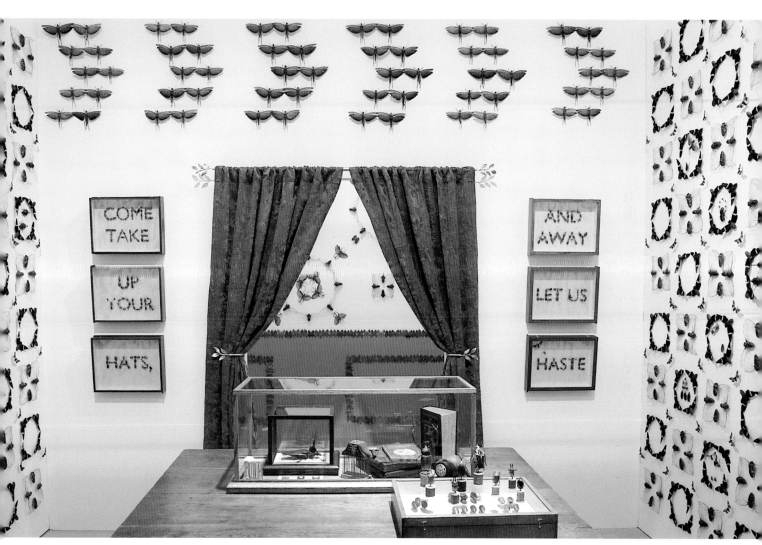

Jennifer Angus
Goliathus Hercules, installation
at the John Michael Kohler Art
Center, Sheboygan, Wisconsin,
USA, 2004
Insects and mixed media
Photo: Jennifer Angus

The subject-matter for Applied Art has also been appearing in the fine arts for decades, but here too it is a growing storm. *The Real Ideal: Utopian Ideals and Dystopian Realities* at the Millennium Gallery in Sheffield, December of 2005, an exhibition designed to 'take a walk on the dark side, [exploring] the tension between utopian visions and the sinister undertones of modern life' is one of many recent shows to take this route. It included Cornelia Parker's *Thirty Pieces of Silver* (2003), 30 silver-plated objects, crushed by a 250-ton industrial press and levitated from ceiling with wires, creating homewares that appear to have been transformed by optical sorcery. China's gifted polymath Ai Weiwei (a conceptual artist, curator, organiser, activist, publisher and designer) also explores the domestic. His famous three-part photograph, *Dropping a Han Dynasty Urn* (1995/2004), in which he lets a perfect 2000-year-old pot shatter on the ground, while intoning, 'It was industry then, it is industry now', forces us to look at antiquities as though they were made today by factories. In other works he paints early Han pots with brightly coloured wall paint (and they look very handsome in their new clothes). Weiwei also makes Siamese-twin and paraplegic furniture, combining several tables into one, while others are missing key 'limbs'.

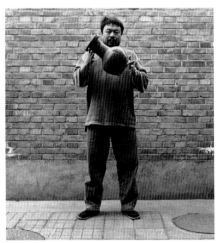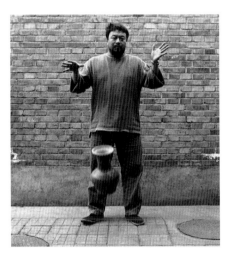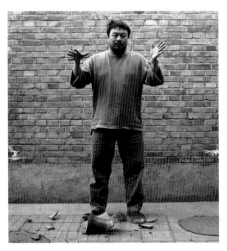

Ai Weiwei
Dropping a Han Dynasty Urn
1995/2004
Various sizes
Black and white photographic
silver print
Photo: Galerie Urs Meile, Beijing–Lucerne

Australia's Timothy Horn came to prominence by raiding the bedroom's jewellery box and enlarging brooches to become 1.5-metre high relief sculptures. In *Purple Rain* (2002), he uses lead crystal, nickel-plated bronze and Easter-egg foil to make this 1-metre long sculpture. In *Medusa* (2006), he exploded the lampshade into an 363-kg, 2.5-metre diameter behemoth of silicone rubber, copper tubing and fibre-optic lighting. Canadian artist Jennifer Angus makes rooms that from a distance appear surfaced in complex-patterned wallpaper but when one gets closer are

Cornelia Parker
Thirty Pieces of Silver 2003
30 silver-plated objects,
crushed by a 250-ton industrial
press, metal wire
Photo: The artist and Frith Street Gallery,
London

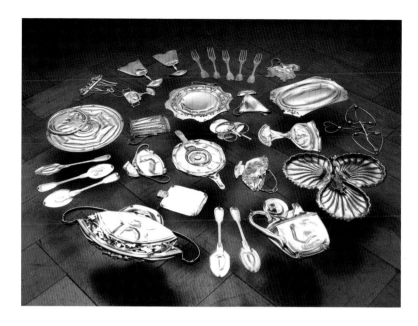

actually thousands of insects pinned to the wall to create pattern and colour.
It is a bizarre but riveting embrace of entomology and decorative art. The artist
explores ideas of home and comfort but filtered through her fascination with
insects and disease.

There is little, if any, difference (aside from the venue in which it is seen) between
the work of the fine artists listed above and the self-identifying 'applied artists'.
This suggests that Applied Art is a transitional movement, particularly if it resists
the urge to institutionalise. Before this decade is over it will most likely be fully
integrated within the fine arts. One can already see this drift beginning to happen.
One might find this all to be confusing. Superficially, Craft and Applied Art have
much in common. What makes one porridge bowl the product of Applied Art, and
another, Craft? There is a simple if unconventional device to tell one from the other:
it is the Wilma and Jane Test. I refer respectively to the lead housewives of two
classic early 1960s Saturday-morning TV cartoon series from Hanna-Barbera
Studios, *The Flintstones* and *The Jetsons*. Wilma represents the housewife of the
Craft world, living happily in her truth-to-materials home that is handcrafted from
rock and dinosaur bones. Jane, the poster girl for Applied Art, lives in a futuristic,
technocratic environment (although it has less of the future and more of today with
each passing decade). However, our Jane is not a happy cartoon-camper any longer.
She suffers from DUE (Domestic Utopian Ennui), as her signature ditty on the show
'I have the press-button blues' always suggested. Relief from this condition comes
from invoking the dysfunctional to relieve the torpor of perfection. So, when one
is confronted by an object and is unsure as to which of the Reform twins authored
the work, try to imagine it first in Wilma's home and then in Jane's. Wherever it feels
most comfortable will place that object in the Craft tradition or the new Applied Art
movement. Happy comparisons, happy shopping.

Garth Clark, art dealer and author, New York City, USA

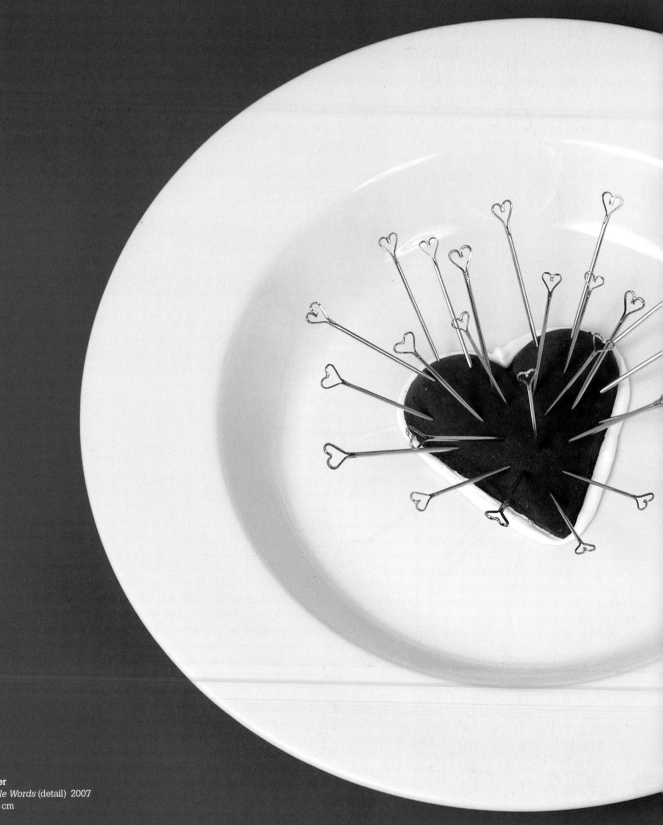

Hans Stofer
With Simple Words (detail) 2007
48 × 48 × 8 cm
Porcelain
Photo: S. van Hul
Artist represented by Galerie S O. Switzerland

Exhibitors

Alpha House Gallery

Founded in 1991, the Alpha House Gallery has a tradition of exhibiting national and international ceramics. Gallery exhibitions include the vessel form, sculptural work and that which relates to concerns of architecture and space, and cross-cultural influences.

Staff
Suzanne Marston, Director
Tim Boon, Consultant

Artists represented
Halima Cassell
Sandra Eastwood
Gabriele Koch
Jacqueline Yu-Fan Li
Jane Perryman

Contact
South Street, Sherborne
Dorset, DT9 3LU, UK
Telephone: +44 (0) 1935 814 944
Fax: +44 (0) 1935 814 944
Email: suzanne.marston@
alpha-house.co.uk
www.alpha-house.co.uk

Halima Cassell
R.E.M. 2006
Diameter 18 cm
Unglazed clay
Photo: Jonathan Keenan

'My work combines strong geometric elements with recurrent patterns and architectural principles. I also utilise definite lines and dynamic angles. I concentrate on simple forms as a basis of my work in order to maximise the impact of the complex surface pattern in combination with heavily contrasting contours.'
Halima Cassell

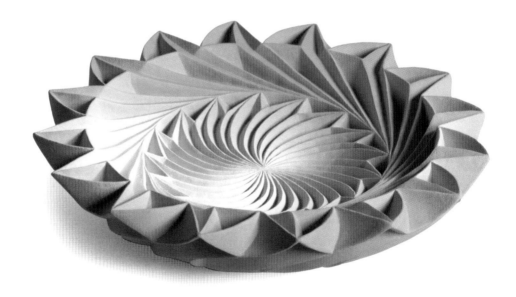

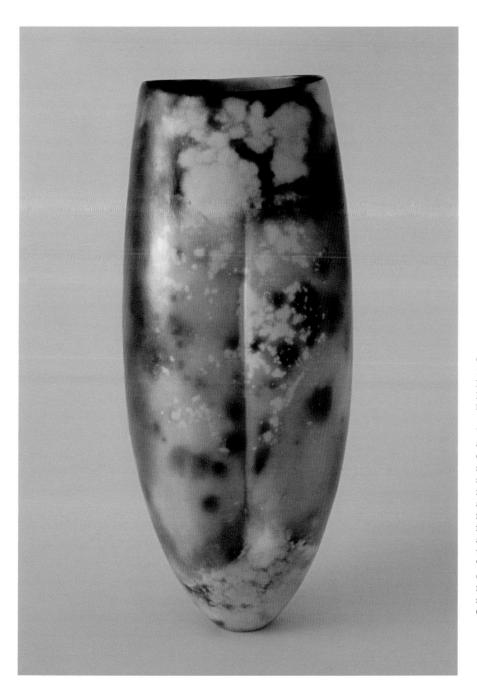

Gabriele Koch
Tall Standing Form 2007
Height 58 cm
Modified T material
Photo: Kelpie

'I am interested in the vessel
as an abstract sculptural
object. I am concentrating on
simple, essential forms, which
sometimes emphasise the
relationship between internal
and external space or the
movement or stillness within the
form. All pieces are hand built
and burnished to achieve a
vibrant, tactile, sensual surface.
The distinctive patterning that
complements the form is the
result of a carefully organised,
secondary carbonising firing.'
Gabriele Koch

Alternatives Gallery

Alternatives Gallery, located in the heart of Rome, was founded in 1997 and specialises in contemporary jewellery. The gallery promotes artists from all over the world, both on a permanent basis and by means of solo and group exhibitions each year.

Staff
Rita Marcangelo, Director

Artists represented
Adrean Bloomard
Mari Ishikawa
Karin Kato
Ute Kolar
Constantinos Kyriacou
Sonia Morel
Ermelinda Magro
Kazumi Nagano
Ramon Puig Cuyás
Marzia Rossi
Giovanni Sicuro
Peter Skubic
Janna Syvänoja
Michelle Taylor
Barbara Uderzo
Andrea Wagner

Contact
Via d'Ascanio 19
00186 Rome, Italy
Telephone: +39 0 6683 08233
Fax: +39 0 6683 08233
Email: info@alternatives.it
www.alternatives.it

Peter Skubic
Like a Temple 2001
3 × 7.5 × 5 cm
Stainless steel, niello, gold leaf
Photo: Peter Skubic

Peter Skubic has always worked primarily with steel. In the early days his 'tension' brooches consisted of taut cables combined with steel, resembling electrical structures. In his latest works from 2000 onwards, we still see the use of steel, a material with which he feels very 'comfortable', although now developing the concept of reflection and refraction, using the inclination of the metal at different angles, together with colour and loose wires, to achieve diverse optical effects.

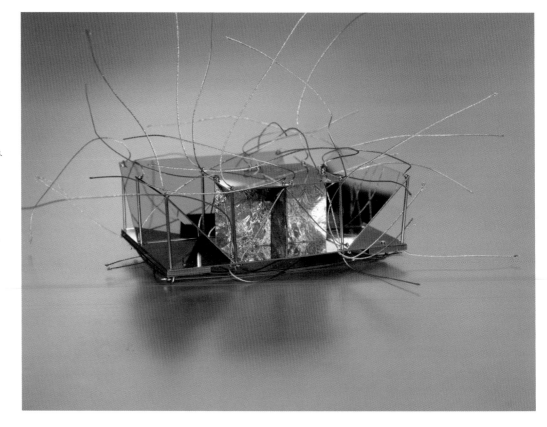

Untitled 2007
Height 10 cm
Silver, polyester wire
Photo: Thierry Zufferey

This supple bracelet, like many of Sonia Morel's works, is based on movement and flexibility. The suppleness in her pieces seems to communicate an inclination to adaptability, the possibility of adjusting the piece to the wearer's body, interacting in a playful movement and becoming an intimate object for the wearer. Transformation is also of great importance to the artist. Many of Morel's pieces present the possibility of reconfiguring their original form or size.

Australian Contemporary

Australian Contemporary presents Australian craft and design to audiences at select international events. Australian Contemporary is an initiative of the Visual Arts Board of the Australia Council, the Federal Government's arts-funding body through the Australia Council and JamFactory International Craft Initiative (ICI).

Staff
Stephen Bowers, Managing Director
Pauline Griffin, Sales Director
Margaret Hancock, Project Co-ordinator

Artists represented
Sean Booth, Metal
Jane Bowden, Metal
Kirsten Coelho, Ceramics
Matt Dwyer, Metal
Bruce Nuske, Ceramics
Kaye Pemberton, Ceramics
David Pottinger, Ceramics
Christopher Robertson, Metal
Jane Sawyer, Ceramics
Julie Shepherd, Ceramics
Oliver Smith, Metal
Kenji Uranishi, Ceramics
Anna Varendorff, Metal

Contact
c/o JamFactory Contemporary Craft and Design
19 Morphett Street, Adelaide
South Australia, 5000, Australia
Telephone: +61 (0) 8 8410 0727
Fax: +61 (0) 8 8231 0434
Email: stephen.bowers@jamfactory.com.au
www.jamfactory.com.au

Jane Sawyer
Teapot and Two Cups 2003
Teapot: 18 × 16 cm
Cups: 8 × 9 cm
Red earthenware glaze, wheel thrown and manipulated
Photo: Terence Bogue

'The slow, dreamy spirals that meander up the sides of [Jane Sawyer's] shallow bowls, the unaffected informality of rim or contour, the way thick creamy slip flows as if by some natural, spontaneous means, all contribute to a feeling of relaxed insouciance. That some of these vessels have holes in their sides instead of handles adds a jaunty note of titillation. These teasing vessels are finely balanced between awkwardness and elegance, indolence and vitality, playfulness and solemnity. They are for ever in a state of becoming.'
Peter Timms, art critic and author, 2007

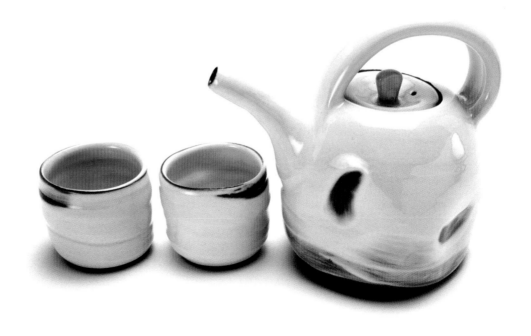

Jane Bowden in collaboration with glass artist Emma Petersen
Here is My Spout 2003
17 × 27 × 21 cm
Sterling silver, blown and hand-finished glass
Photo: Grant Hancock

'The rings, bracelets, neckpieces and brooches of jeweller-metalsmith Jane Bowden are both enduringly elegant and breathtakingly bold. In a collaboration with a glass artist, an ongoing series of sculptural glass and metal teapots features exquisite woven silver details that reference Indigenous Australian basketry, as well as the traditional woven components of oriental teaware. They are complemented by intricately woven gold/silver tea strainers, in which an effusion of unworked silver strands provides a trademark flourish.'
Wendy Walker, writer and curator, 2007

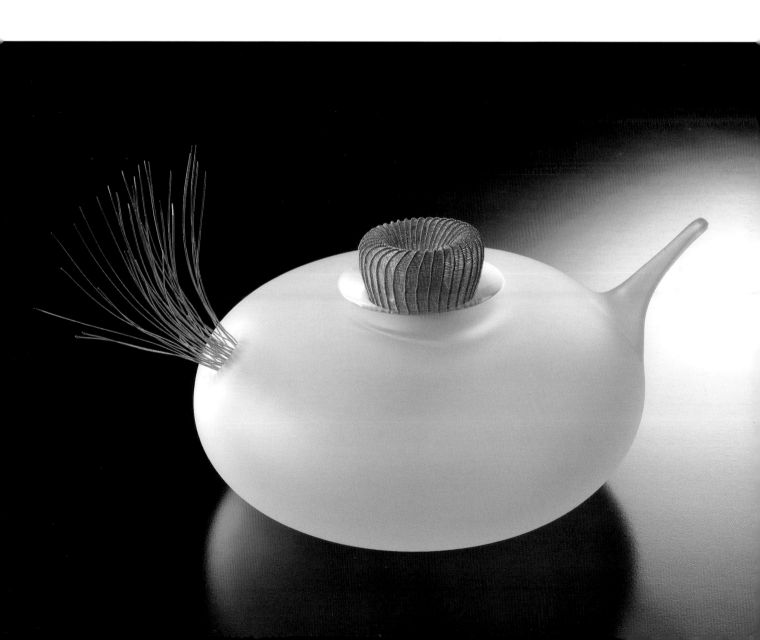

Bishopsland Educational Trust

Bishopsland is a postgraduate training workshop for high-flying silversmiths and jewellers. Its one-year residential course provides a bridge between college and professional practice. Tutors, fellows and current students have come together to exhibit at Collect 2008.

Staff
Penelope Makower
Lin Cheung
Angela Cork
Oliver Makower
Zillah Puri
current course members

Artists represented
Malcolm Appleby, Metal
Shimara Carlow, Metal
Angela Cork, Metal
Ndidi Ekubia, Metal
Miriam Hanid, Metal
Rod Kelly, Metal
Momoko Kumai, Jewellery
Rebecca Little, Jewellery
Nan Nan Liu, Metal
Helen London, Metal
Wayne Meeten, Metal
Pete Musson, Metal
Theresa Ngyuen, Metal

Clare Ransom, Metal
Linda Robertson, Metal
Jacquelin Scholes, Metal
Jane Short, Metal
Karen Simpson, Metal
Pete Stevens, Metal
Megumi Toyokawa, Metal

Contact
Bishopsland, Dunsden
South Oxfordshire
RG4 9NR, UK
Telephone: +44 (0) 11 8972 4550
Fax: +44 (0) 11 8972 4550
Email:
omakower@compuserve.com
www.bishopsland.org.uk

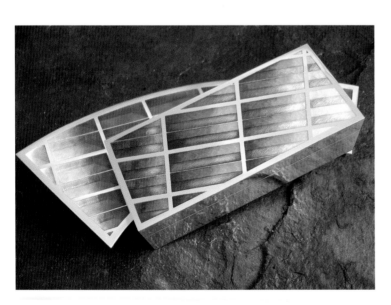

Jane Short
Hinged Box with Intersecting Plane 2006
3.6 × 9.7 × 4.8 cm
Silver, enamel
Photo: Jane Short

The focus of Jane's work is that of a constant dialogue and enquiry into the richness and subtlety of colour that the technique of enamel can offer. Pattern and closely observed nuances of detail are expressed through engraving and enamelling on both smaller- and larger-scale pieces of silverware.

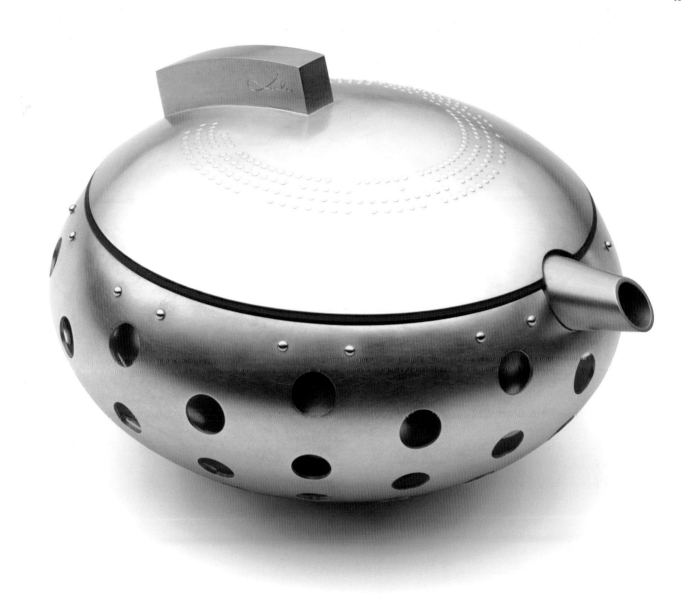

Linda Robertson
Handless Teapot for Lulu
2005–6
Height 12 cm, diameter 18.5 cm
Silver, 9-carat gold, 3 microns;
hand gold plating and insulating
thermal plastic
Photo: Shannon Tofts

This handless teapot was
commissioned for sixties icon
Lulu in the exhibition *Silver
of the Stars* by the Worshipful
Company of Goldsmiths,
Edinburgh, under the theme of
a drink with a friend. The piece
takes its inspiration from the tea
ceremonies of the East and the
gentle curves of the stacking
stones of a feng-shui garden.

Bluecoat Display Centre

The Bluecoat Display Centre's selected artists reflect the quality and diversity of contemporary applied art being produced in north-west England and beyond, and exhibited at the Display Centre during 2008, Liverpool's year as European Capital of Culture

Staff
Maureen Bampton, Director
Samantha Rhodes, Assistant Director

Artists represented
Laura Baxter, Metal
Li-Sheng Cheng, Metal
Stephen Dixon, Ceramics
Rebecca Gouldson, Metal
Thomas Hill, Metal
Mari-Ruth Oda, Ceramics
Emma Rodgers, Ceramics/Metal
Edward Teasdale, Furniture

Contact
College Lane, Liverpool
Merseyside, L1 3BZ, UK
Telephone: +44 (0) 151 709 4014
Fax: +44 (0) 151 707 8106
Email: crafts@
bluecoatdisplaycentre.com
www.bluecoatdisplaycentre.com

Rebecca Gouldson
Triptych 1 2007
Each panel: height 48 cm, width 16 cm
Etched and patinated gilding metal
Photo: Rebecca Gouldson

'My ideas stem from the built environment, in particular from scarred and eroded architectural façades: peeling wallpaper revealing patterns of mould and mildew, the remains of a staircase on a half-demolished building, protruding pipes and electricity wires. Using etching techniques more traditionally used by printmakers, I create Metal Wall Pieces with richly decorated surfaces; "drawing" into and on to the surface of metal with a palette of acid-etching and patination techniques.'
Rebecca Gouldson

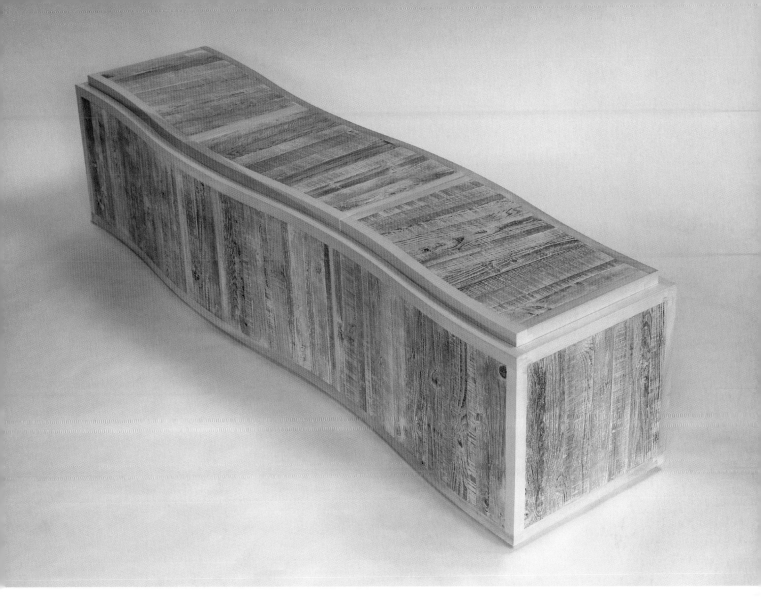

Ed Teasdale
Chest (with three lids) 2007
45 × 200 × 48 cm
Reclaimed wood and tulip
Photo: Graham Edwards

'I work with wood collected
from the landscape, shorelines
etc, where it has lain and
taken on a weathered surface.
Because the pieces found
are small in size objects are
assembled (using traditional
joinery and cabinet making)
from a large number of these
elements. Surfaces are treated
to emphasize the textures and
colours of the weathered wood.
All surfaces are sealed and
external surfaces are waxed.'
Ed Teasdale

Clare Beck at Adrian Sassoon

Clare Beck and Adrian Sassoon present contemporary British studio ceramics, glass, silver and jewellery, from museum-quality work to more modestly priced pieces. For Collect 2008 we are presenting a special exhibition of *Monumental Pots* by four artists to encourage the collection of large-scale and site-specific work either for the interior or within the landscape.

Staff
Clare Beck
Adrian Sassoon
Kathleen Slater
Andrew Wicks
Mark Piolet

Artists represented
Felicity Aylieff, Ceramics
Tessa Clegg, Glass
Gerda Flöckinger CBE, Jewellery
Elizabeth Fritsch CBE, Ceramics
Chris Knight, Metal
Kate Malone, Ceramics
Junko Mori, Metal
Adam Paxon, Jewellery
Colin Reid, Glass
Bruno Romanelli, Glass
Hiroshi Suzuki, Metal
David Watkins, Jewellery
Neil Wilkin, Glass
Rachael Woodman, Glass

Monumental Pots
Felicity Aylieff, Ceramics
Kate Malone, Ceramics
Rupert Spira, Ceramics
Julian Stair, Ceramics

Contact
By appointment only:
14 Rutland Gate
London, SW7 1BB, UK
Telephone: +44 (0) 20 7581 9888
Fax: +44 (0) 20 7823 8473
Email: email@adriansassoon.com
www.adriansassoon.com

Kate Malone
A Gigantic Pippy Vase 2005
75 × 56 × 56 cm
Crystalline-glazed stoneware
Photo: Stephen Brayne

Kate Malone approaches her large-scale work with the usual gusto and *joie de vivre* that is synonymous with all her work. Inspired by succulent plants that grow over rocks and walls in the Provençal countryside, *A Gigantic Pippy Vase* is a *Monumental Pot* with amplified decoration that rhythmically enhances the form. As Kate says, 'The dressing of the surface is as if we are preparing it for a special occasion, almost *embroidering* a complicated dress on the surface.

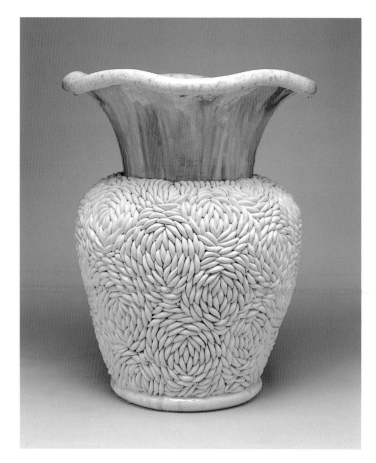

Hiroshi Suzuki
Dual-Rivulet Fire 2007
22.5 × 35 × 35 cm
Hammer-raised, double-skinned,
Britannia silver 958
Photo: Matthew Hollow

Hiroshi Suzuki has continued
to develop his double-skinned
bowls over the last few years.
Dual-Rivulet Fire is a real *tour
de force*, hand-raised from two
sheets of silver and brought
together to form a wonderful,
expansive vessel. Hiroshi has
used different textures inside
and out, demonstrating his
extraordinary prowess with
the material and creating
an object that has a noble
presence. Similar pieces
are in the collections of the
National Museum of Scotland,
Edinburgh, and the Museum
of Arts & Design, New York.

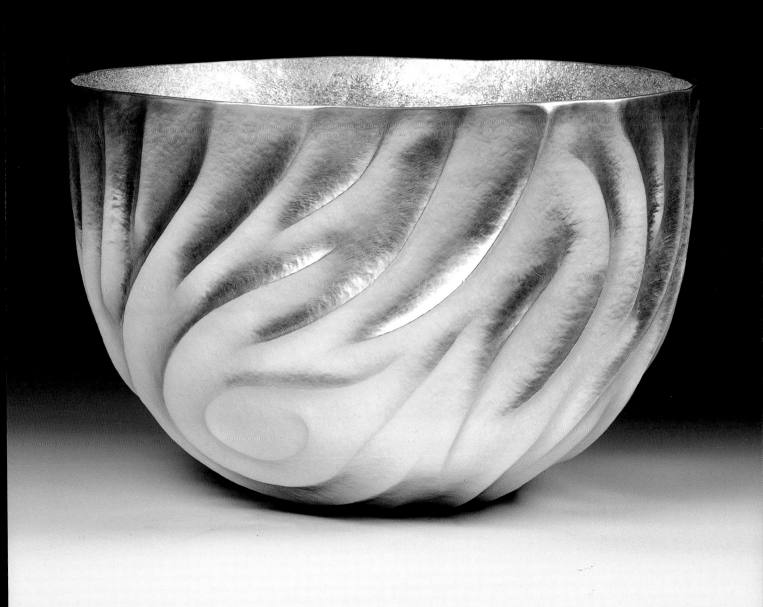

Cockpit Arts

Cockpit Arts supports and promotes the work of applied artists and designer-makers through all stages of their career – from first beginnings through to international success. It is the largest creative community of its kind in the UK, housing 165 artists in its two London studio centres. The jewellers represented were selected by an expert panel: Corinne Julius, design critic, Janice Tchalenko, ceramicist, and Julie Lomax, Senior Visual Arts Officer, Arts Council London. Artists may be visited by appointment.

Staff
Vanessa Swann, Chief Executive
Lucy Everett, Sales Development Manager

Artists represented
Jane Adam
Kelvin Birk
Jacqueline Cullen
Sarah King

Contact
Cockpit Yard, Northington Street
London, WC1N 2NP, UK
Telephone: +44 (0) 20 7419 1959
Fax: +44 (0) 20 7916 2455
Email: lucy@cockpitarts.com
www.cockpitarts.com

Sarah King
Bangle 2006
11 × 13 × 11 cm
Bioresin and sterling silver
Photo: Jeremy Johns Photography

Sarah King explores light, space, absence and transparency within her cast bioresin and constructed precious-metal jewellery. Pieces are conceived and exhibited in series to accentuate their relative abstract qualities.

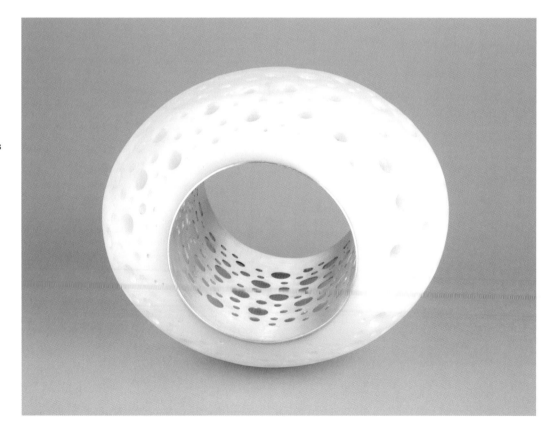

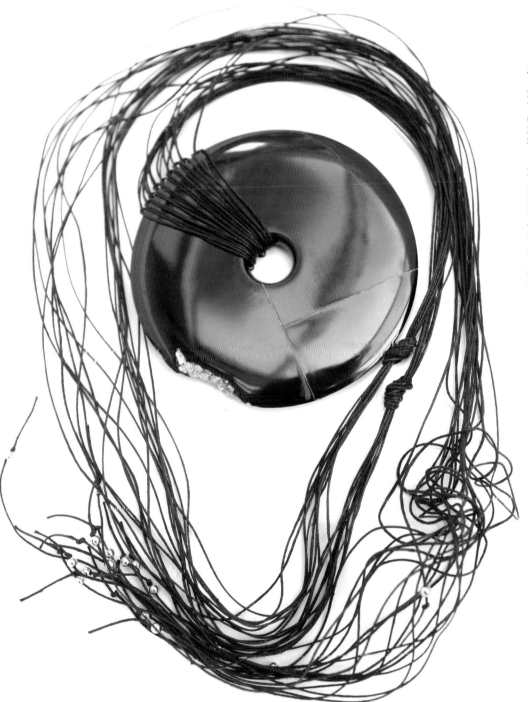

Jacqueline Cullen
Whitby Jet Pendant 2007
Height 100 cm, width 9 cm
Whitby jet, lined with 24-carat
gold, 18-carat-gold beads,
linen threads
Photo: Nick Turner

Jacqueline Cullen uses
Whitby jet, a rare pre-historic
black fossilised wood, most
commonly associated with
Victorian mourning jewellery,
to create contemporary pieces.
Cullen celebrates the inherent
qualities of the material by
creating bold, fluid forms, with
threads of fine gold tracing the
surface or black-diamond
encrusted crevices.

Contemporary Applied Arts

Contemporary Applied Arts (CAA) is London's largest gallery of contemporary applied art, representing over 300 innovative artists within ceramics, glass, furniture, jewellery, metal, paper, silver, textiles and wood. The gallery has promoted and sold the best of British craft since 1948 and will celebrate 60 years of success throughout 2008.

Staff
Sarah Edwards, Director
Clare Maddison, Retail Manager
Lucy Southgate, Sales

Artists represented
Zoe Arnold, Jewellery
Vladimir Böhm, Silver
Christie Brown, Ceramics
Helen Carnac, Metal
Lin Cheung, Silver
Bob Crooks, Glass
Sally Fawkes, Glass
Gillies Jones, Glass
Natasha Kerr, Textiles
Craig Mitchell, Ceramics
Gareth Neal, Furniture
Mah Rana, Jewellery
Elly Wall, Ceramics
Chien-Wei Chang, Silver

Contact
2 Percy Street
London, W1T 1DD, UK
Telephone: +44 (0) 20 7436 2344
Fax: +44 (0) 20 7636 6269
Email: info@caa.org.uk
www.caa.org.uk

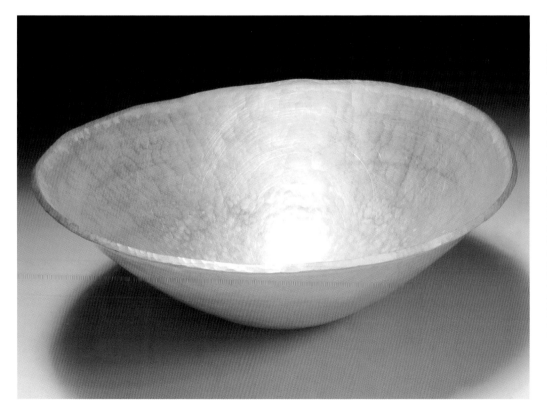

Vladimir Böhm
Open Vessel 2006
Height 10 cm, diameter 30 cm
Silver
Photo: Andre Nelki

Vladimir Böhm uses precious metals, including gold and silver, to which he applies glass enamel in iridescent colours and thereby transforms the unusual vessels into individual and unique objects. He has won numerous prizes from guilds, professional organisations and the media. His work has been exhibited widely through galleries and museums internationally. Vladimir's work can be found in many private and public collections including the Victoria and Albert Museum, London, Calouste Gulbenkian Foundation, 401 Collection, Elmsfield, Aberdeen Art Gallery & Museums and Corpus Christi Centre, Bournemouth.

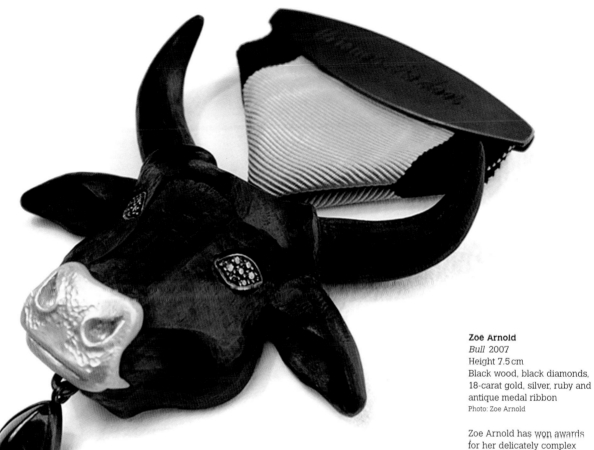

Zoe Arnold
Bull 2007
Height 7.5 cm
Black wood, black diamonds,
18-carat gold, silver, ruby and
antique medal ribbon
Photo: Zoe Arnold

Zoe Arnold has won awards
for her delicately complex
style, producing pieces that
are individual and desirable
one-offs. Works include not
only precious metals and
gem-stones but sometimes
also collected objects such as
mother-of-pearl gaming chips,
antique microscope lenses,
ribbons and prints. Zoe's
combinations of found objects
and precious materials strike
unusual chords, which offer
a different resonance and depth
for each beholder, tempting you
to delve beneath the surface.

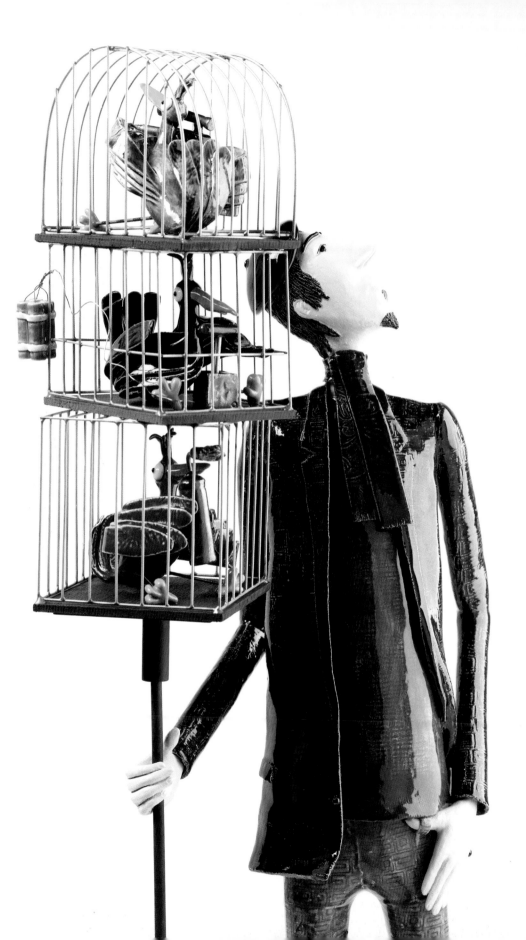

Craig Mitchell
Bird Vendor 2006
Height 80 cm
Ceramic
Photo: Shannon Tofts

Craig Mitchell's work not only
explores contemporary culture
and universal themes but also
responds to current events,
both political and personal.
As he says, 'Everything in my
life, every chance comment,
every potentially insignificant
interaction and childhood
memory is mixed into the
melting pot of my work.
Realising slightly surreal
ceramic creations is my way
of relating to the increasingly
bizarre reality that forms the
fabric of our daily lives.'

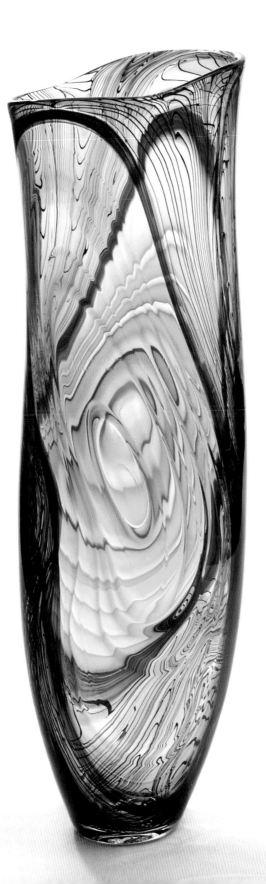

Bob Crooks
Contour Vase 2007
Height 70 cm
Blown glass
Photo: Ian Jackson

Bob Crooks is one of Britain's
most renowned glassmakers.
His work is inspired by
architecture, nature and
geometry. Constantly pushing
the boundaries of the material,
he exploits glass's properties
of reflection and refraction,
transparency and opacity,
fluidity and freezing. The
dynamic use of line runs
through his work, utilising a
variety of techniques to create
movement within the pattern
and form. Bob's work is to be
found in many international
collections including London's
Victoria and Albert Museum,
the National Museums of
Scotland, Coburg Museum,
Germany, and the Mobile
Museum, Alabama, USA.

Contemporary Art Gallery

Lilly Zeligman bases the exhibition policy on the careful selection of artists whose work displays a 'sense of reality', either magical-realist or surrealistic. This accounts primarily for the two-dimensional media of painting and photography. The gallery also exhibits contemporary jewellery and small-scale sculptures in glass, stone, bronze or ceramics.

Staff
Lilly Zeligman, Gallery Owner

Artists represented
Mecky Van Den Brink, Jewellery
Arianne van der Gaag, Jewellery
Jeanne Opgenhaffen, Ceramics
Monika Seitter, Jewellery
Piet Stockmans, Ceramics
Anne Rose Regenboog, Jewellery
Joke Schole, Jewellery
Rina Tairo, Jewellery

Contact
Torenlaan 8, Laren
1251 HJ, The Netherlands
Telephone: +31 (0) 35 5414787
Fax: +31 (0) 35 5411496
Email: info@cag-laren.nl
www.cag-laren.nl

Jeanne Opgenhaffen
With Simple Words (detail)
2007
48 × 48 × 8 cm
Porcelain
Photo: S. van Hul

Belgian artist Jeanne Opgenhaffen is internationally recognised for her work with coloured porcelain. Her large murals are constructed from thousands of tiles, which are overlapped in varying shades and tones. Over the years, her work has developed from the figurative to the abstract. Her influences are the landscape and rock strata. The earth's layers are re-created through subtle colour changes, and her works convey a sense of movement, like a breeze blowing across a field, changing the colour of the vegetation.

Anne Rose Regenboog
Untitled – collier 2007
Diameter 25 cm
Romanium, silver
Photo: Aatjan Renders

The jewels of Anne Rose
Regenboog are best defined
as dynamic jewel art. Her work
has been based on elementary
forms, such as the circle,
triangle or the pyramid. She
considers each new design as
a challenge: they are carefully
built pieces, the final result of
a creative process.

Contemporary Ceramics

Contemporary Ceramics is a specialist gallery with the aim of promoting work that reflects the diversity and vitality of contemporary ceramic art.

Staff
Marta Donaghey

Artists represented
Eddie Curtis
Lisa Hammond
Gareth Mason
Phil Rogers
Antonia Salmon
John Ward

Contact
7 Marshall Street
London, W1F 7EH, UK
Telephone: +44 (0) 20 7437 7605
Fax: +44 (0) 20 7437 7605
Email: contemporary.ceramics@
virgin.net
www.cpaceramics.com

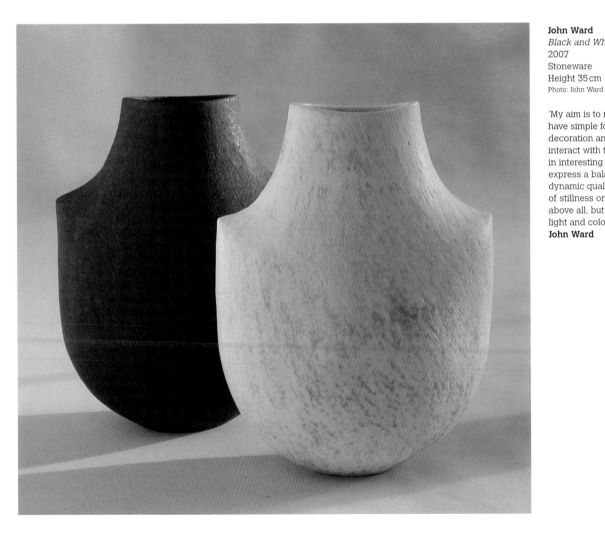

John Ward
Black and White Shoulder Pots
2007
Stoneware
Height 35 cm
Photo: John Ward

'My aim is to make pots which have simple forms with integral decoration and aspects that interact with the environment in interesting ways; to try to express a balance between these dynamic qualities and a sense of stillness or containment. Form above all, but expressed through light and colour.'
John Ward

Jar 2007
Height 70 cm
Stoneware, porcelain, layered
slips, glazes, mineral deposits
Photo: Lakeland Arts Trust

'I want to bypass the
rationalising constraint of
hard-won technique and the
"hard-wiring" accrued through
years of habit. So I dig rocks
and minerals and fire them
unprocessed, as a foil to
my ceramic dogma. This
compulsion has unmasked all
the latent tensions in my work.
My delight in the volupté of soft
porcelain is now augmented
with visceral textures and the
blackest corrosion. This is a
revelation of extremes. Parched
and encrusted terrain is
traversed by molten rivulets
and conjoined with ice floes.
These qualities are tectonic and
intimate; it is about being whole,
being human.'
Gareth Mason

Craftscotland

Craftscotland, funded by the Scottish Arts Council, is the international showcase for the best of Scottish contemporary craft. Our website, www.craftscotland.org, is a gateway to news about Scottish craft, and at its heart is a searchable directory of Scottish makers.

Staff
Stephen Richard, Chair
Tina Rose, Acting Project Manager

Artists represented
Marianne Anderson, Jewellery
Jilli Blackwood, Textiles
Ray Flavell, Glass
Anna Gordon, Jewellery
Sarah Keay, Jewellery
Sara Keith, Textiles
Anna King, Fibre
Hannah Louise Lamb, Jewellery
Grainne Morton, Jewellery
Deirdre Nelson, Textiles
Graham Stewart, Metal
Andrea Walsh, Ceramics
Simon Ward, Ceramics

Contact
c/o Edinburgh College of Art
Lauriston Place
Edinburgh, EH3 9DF, UK
Telephone:
(UK) 0845 222 0348
(International)
+44 (0) 131 447 6575
Email: enquiries@craftscotland.org
www.craftscotland.org

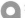
Scottish
Arts Council

Ray Flavell
Aspiration 2006
43 × 59 × 59 cm
Glass
Photo: Shannon Tofts

'I use craft to make art, so glass becomes a medium of artistic expression. Currently I am looking at conventional glass artefacts like bowls and phials in combination with flat glass panels. These compositions explore the delicacy and precarious fragility of glass and at the same time are enigmatic. This is new work that is not bound up in complicated technique but I hope celebrates some of the finite characteristics of glass and glassmaking.'
Ray Flavell

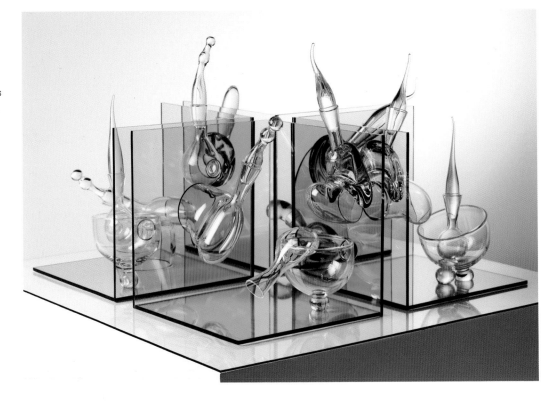

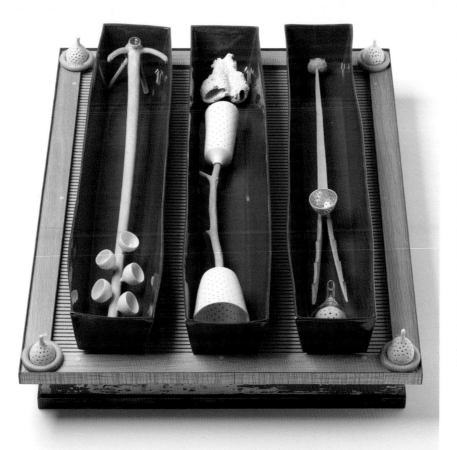

Simon Ward
Archive 2006
15 × 49 × 62 cm
Ceramic
Photo: Shannon Tofts

'Over the past five years
my work has been primarily
concerned with challenging
the roles and contexts of
porcelain in both the interior
and exterior environments.
This has occurred through
cross-cultural exchange via
residency programmes in
Japan and Europe. Forming
connections and relationships
between porcelain and wood,
metal, concrete and other found
materials has resulted in work
that challenges the role of
this material and its potential
current/future contexts. One
of the main themes involves
researching how ordinary
functional objects have been
given a new role and context.
Current conclusions involve
the forming of collections that
question, explore and challenge
function.'
Simon Ward

Cultural Connections CC

Cultural Connections CC aims to promote and consolidate the very high standard and beauty of Danish contemporary classic ceramics. The gallery aims to increase awareness of: the range of techniques involving form, materials and glazes the represented artists strive constantly to develop and achieve; how each of the artists works with the concept of the ancient vessel form and its many possibilities, from original functionality to pure art.

Staff
Birthe Nørgaard Fraser, Director
Pernille Fraser
T. W. Fraser

Artists represented
Beate Andersen
Aase Haugaard
Peder Rasmussen
Inger Rokkjaer
Hans Vangsø
Ivan Weiss

Contact
Kylling House
29 Elmtree Green
Great Missenden
Buckinghamshire
HP16 9AF, UK
Telephone: +44 (0) 1494 866 803
Fax: +44 (0) 1494 866 803
Mobile: 07872962199
Email:
fraserartconsult@talk21.com
www.culturalconnections.co.uk

Beate Andersen
Tibetan Locks 2007
18 × 18 × 18 cm
Hand-painted stoneware
Photo: Beate Andersen

'While the clay grows & the pot forms between my hands, the meditative moment comes when my consciousness turns in the direction of that which knows I am forming a pot. My intention is – as I sense these feelings – to try to create forms, glazes and figures which to me communicate this power.'
Beate Andersen (*Ceramic Ways*, 2000)

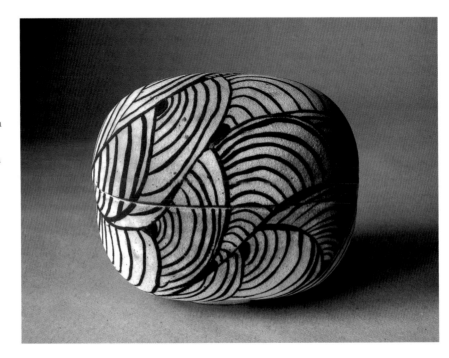

Inger Rokkjaer
Red Lidded Fluted Jar 2007
Height 17 cm, diameter 17.5 cm
Ceramic, raku-fired
Photo: Erik Balle Povlsen

'Her pots have structured
clarity. Offset by rich luminous
colour and developed tonal
and textural modulation. The
surfaces achieve depth through
their varied densities of crackle
pitting and smokiness. The
objects are also inherently
Danish. Earthenware is a
traditional Jutland body still
widely employed and her pots
are confidently Scandinavian
in their economy. They have
that particular understatement
long associated with Danish
functionalism.'
David Whiting (foreword to
Lidded Jars, Inger Rokkjaer,
2004)

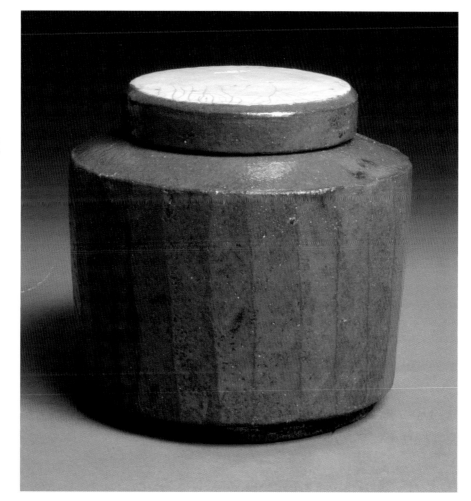

The Devon Guild of Craftsmen

The Devon Guild of Craftsmen represents makers from the south-west of England and is the focus for crafts activity throughout the region. Work represented at Collect builds on strengths in ceramics and furniture, introducing exciting regional talent in this international arena.

Staff
Tam Holman, Shop Manager
Saffron Wynne, Exhibitions Officer
Simon Williams, Marketing Officer

Artists represented
Tim Andrews, Ceramics
Svend Bayer, Ceramics
Matthew Burt, Furniture
Nic Collins, Ceramics
Tim Gee, Ceramics
Carl Hahn, Furniture
Robert Kilvington, Furniture
Susan Kinley, Glass/Textiles
John Makepeace, Furniture
Anne Smyth, Glass
Rob Sollis, Ceramics

Contact
Riverside Mill, Bovey Tracey
Devon, TQ13 9AF, UK
Telephone: +44 (0) 1626 832 223
Fax: +44 (0) 1626 834 220
Email: devonguild@crafts.org.uk
www.crafts.org.uk

Sue Kinley
Field of Sails 2007
Height 117 cm, width 79 cm
Glass, silk, metal gauze, digital print
Photo: Rob Jewell

'In *Field of Sails* I have shifted focus to move in and out of the same landscape, from an overview to enlarged detail. Small, repeating fragments of imagery on glass are held in a field of printed and layered silk and metal gauze. These elements of manmade marks on the landscape form part of the pattern of continual change, assuming their own beauty and history as we forget what went before.'
Sue Kinley

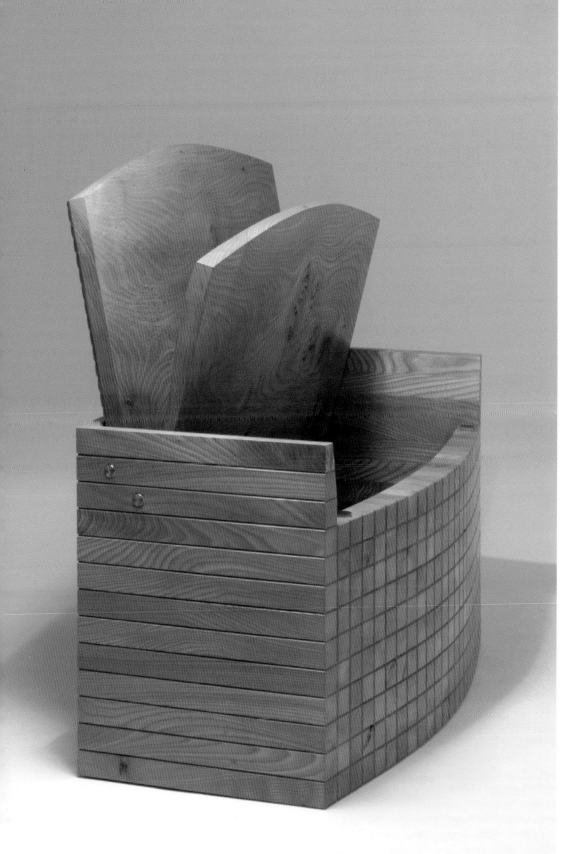

Matthew Burt
Bench Chest 2003
46 × 140 × 56 cm
Elm-wood
Photo: Ikon Studios

'This bench chest represents part of my series of epitaphs to the towering elms of my youth. This awkward, cussed timber does not give up its charms without a fight.'
Matthew Burt

Matthew designs in response to a client's brief in his commissioned work and in response to his own brief in his speculative work. The crossover of these journeys is the engine of his creativity.

Flow

Flow, founded in 1999 in Notting Hill, London, specialises in both international and British contemporary applied arts. The gallery represents over 200 artists.

Staff
Yvonna Demczynska
Sachiko Ewing
Beccy Gillatt

Artists represented
Dali Behennah, Basketry
Sarah Kay, Furniture
Karen Klim, Glass
Åse Ljones, Textiles
Anna Polanská, Glass
Liske Russell de Boer, Furniture
Kati Tuominen-Niittylä, Ceramics
Ulla-Maija Vikman, Textiles

Contact
1–5 Needham Road
London, W11 2RP, UK
Telephone: +44 (0) 20 7243 0782
Fax +44 (0) 20 7792 1505
Email: info@flowgallery.co.uk
www.flowgallery.co.uk

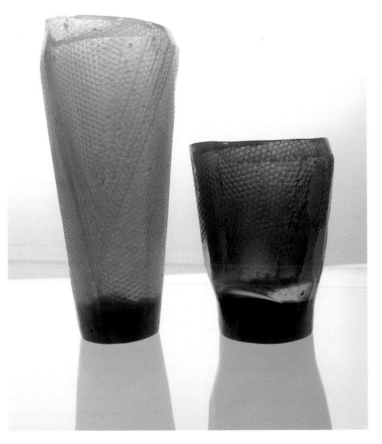

Anna Polanská
Left: *Medová velká (Honey Landscape, Large)* 2006
39 × 14 × 14 cm
Right: *Medová malá (Honey Landscape, Small)* 2006
19 × 14 × 14 cm
Glass
Photo: Anna Polanská

Anna Polanská's work reflects her interest in landscape and the human form. She is also fascinated by the plasticity of the material, which she regards as its most important quality. In her vessels, created by moulding and cutting, Anna seeks to achieve textured forms that could have been made with flint and stone in another era.

Åse Ljones
Maternal Grandmothers 2006
Height 90 cm, length 280 cm
Embroidered linen
Photo: Henriksen

'Through my work I seek
to express the connection
to all our maternal ancestors.
My embroideries are all done
by hand on linen, and then
stretched on to frames. It is
a slow and meditative way
of working. I work in series,
making small changes from one
piece to the next, enjoying the
repetition. Time, calmness and
light are all important elements
in my work.'
Åse Ljones

Galerie für Angewandte Kunst

The Galerie für Angewandte Kunst was created by the Bavarian Crafts Council as a space for excellent contemporary arts and crafts. Seven exhibitions a year present the work of members and international artists.

Staff
Ilona von Seckendorff, Director

Artists represented
Kerstin Becker, Metal/Jewellery
Maike Dahl, Metal
Sophia Epp, Jewellery
Franz X. Höller, Glass
Ulla und Martin Kaufmann, Metal/Jewellery
Eva Reidel, Metal/Jewellery
Sabine Steinhäusler, Jewellery
Agnes von Rimscha, Metal/Jewellery
Annette Zey, Metal

Contact
Pacellistrasse 6–8
D-80333 Munich, Germany
Telephone: +49 (0) 89 2901470
Fax: +49 (0) 89 296277
Email:
info@kunsthandwerk-bkv.de
www.kunsthandwerk-bkv.de

Eva Reidel
Brooches 2004
Top: 8.6 × 3.2 × 0.8 cm
Bottom: 5.5 × 4.9 × 0.8 cm
Silver
Photo: Peter Verburg

Eva Reidel creates jewellery and bowls. Her materials are mostly sheet silver, sometimes gold. Chasing is the technique she prefers. With her hammered and chased bowls she has developed a type of work that is unique among modern silver objects. The jewellery is influenced by nature.

Maike Dahl
Milkman Jugs 2006
Height 18 cm, diameter 10 cm
Silver
Photo: Maike Dahl

Maike Dahl's works combine
perfectly craft and modern
design. She creates silver
tableware for the modern
household. She attaches
importance to excellent
workmanship. Getting her
inspiration from the technique
of paper folding, she folds
sheet silver. This simple
technique brings out a great
variety of forms.

Galerie Hélène Porée

Since 1992 the Galerie Hélène Porée has been dedicated to high-level European applied arts, with the focus on contemporary glass and ceramics.

Staff
Hélène Porée
Marc Porée

Artists represented
Jean-François Fouilhoux, Ceramics
Matei Négréanu, Glass
Carine Neutjens, Glass

Contact
1 rue de l'Odéon
75006 Paris, France
Telephone: +33 (0) 1 43 54 17 00
Fax: +33 (0) 1 43 54 17 02
Email:
info@galerie-helene-poree.com
www.galerie-helene-poree.com

Jean-François Fouilhoux
La Surface des Choses 2006
32 × 36 × 41 cm
Clay, celadon enamel
Photo: Jean-François Fouilhoux

The total dedication to celadon glaze and the subsequent development of his specific plastic language 'happened' to J-F Fouilhoux in 1969 on one momentous encounter with a twelfth-century celadon tiger in the Musée Guimet in Paris. Since then, extensive theoretical research, with innumerable trials has allowed some of the most stunning celadon-glazed contemporary sculptures to be put forth by one European master of this art.

Matei Négréanu
Peur (Fright) 2005
12 × 29 × 34 cm
Glass
Photo: F. Calmont

Négréanu is before everything
an explorer, never repeating
himself, constantly moving
ahead. He is now exploring
a new theme, which he calls
'Cliffs': sunrise-coloured blocks
of glass, sawed, hammered,
scratched with frenzy. A true
sculptural work, brutal and
sensuous. Beauty and violence
of art and nature exalted,
the works of Matei Négréanu
are decidedly and voluntarily
stamped with the seal of
abstraction, dominance of
the artist's gesture on the
employed material.

Galerie Louise Smit

Galerie Louise Smit specialises in contemporary studio jewellery. The all-encompassing nature of the gallery shows the latest developments of the national and international avant-garde.

Staff
Louise Smit
Evert Nijland
Terhi Tolvanen
Robert Smit

Artists represented
Ralph Bakker
Rike Dartels
Doris Betz
David Bielander
Bas Bouman
Helen Britton
Jacomijn van der Donk
Iris Eichenberg
Beppe Kessler
Felix Lindner
Yutaca Minegishi
Marc Monzo
Iris Nieuwenburg
Evert Nijland
Karen Pontoppidan
Robert Smit
Terhi Tolvanen
Truike Verdegaal
Francis Willemstijn
Christoph Zellweger

Contact
Prinsengracht 615
1016 HT, Amsterdam
The Netherlands
Telephone: +31 (0) 20 625 98 98
Fax: +31 (0) 20 428 02 16
Email: gls@xs4all.nl
www.louisesmit.nl

Iris Eichenberg
Châtelaine 2007
19.8 × 7.2 × 2.9 cm
Silver, copper, bone
Photo: Francis Willemstijn

Eichenberg's most recent series of works, inspired by the material remnants of European immigration to the New World, centres on experiences of loss and belonging, dislocation and resettlement, consistencies and transformations in taste.

Terhi Tolvanen
Zig-Zag – necklace 2007
Diameter 18 cm
Porcelain, silver
Photo: Francis Willemstijn

Zig-Zag (*Woodland* series, 2007,
made in EKWC) is about the
interaction between man and
nature. In her jewellery Terhi
focuses not on the damage
caused by man to nature,
but on care and preservation.
The porcelain for the necklace
Zig-Zag was made during a
working period in the European
Ceramic Work Centre in the
Netherlands. She seems able
to visualise the organic clay,
without literally copying
her influences. In this piece
her own designed 'nature' is
combined with silver chains.

Galerie Marianne Heller

The Galerie Marianne Heller for contemporary ceramic art has been presenting ceramic vessels and sculptures by international artists for 30 years. Now representing Rupert Spira, UK, with special guest Pippin Drysdale, Australia.

Staff
Marianne Heller, Director

Artists represented
Pippin Drysdale
Rupert Spira

Contact
Friedrich-Ebert-Anlage 2
Am Stadtgarten
D-69117 Heidelberg, Germany
Telephone: +49 (0) 6221 61 90 90
Fax: +49 (0) 6221 89 36 334
Email: info@galerie-heller.de
www.galerie-heller.de

Pippin Drysdale
Kimberly Series, Pip 2007
Variable height 20–48 cm
Installation closed forms
porcelain
Photo: Adrian Lambert/Robert Frith
Acorn, Australia

Pippin Drysdale, an artist with an international reputation, working in porcelain, was honoured with the Master of Australian Craft Award 2007.

Rupert Spira
Open Bowl 2007
Height 9 cm, diameter 29 cm
Stoneware clay, text embossed
under titanium glaze
Photo: Rupert Spira

'I think of my studio more as
a laboratory than a workplace.
It is a place or, more accurately,
an event, a series of events, in
which the elements of nature –
space, mind, earth, water, line,
fire, movement, form, time –
are gathered, exploring and
expressing that which holds
them together as a cohesive
whole.'
Rupert Spira

Galerie Marzee

Galerie Marzee was founded in 1978 and is the world's largest gallery for modern jewellery. It holds both temporary exhibitions and a permanent collection.

Staff
Marie-José van den Hout, Owner

Artists represented
Giampaolo Babetto
Iris Bodemer
Antje Bräuer
Yu-Chun Chen
Ute Eitzenhöfer
Kathleen Fink
Stephanie Jendis
Rudolf Kocéa
Beate Klockmann
Stefano Marchetti
Christine Matthias
Julie Mollenhauer
Carla Nuis
Barbara Paganin
Francesco Pavan
Ruudt Peters
Annelies Planteijdt
Dorothea Prühl

Ulrich Reithofer
Tabea Reulecke
Sybille Richter
Philip Sajet
Lucy Sarneel
Ann Schmalwasser
Karin Seufert
Vera Siemund
Etsuko Sonobe
Tore Svensson
Karola Torkos
Silke Trekel
Manuel Vilhena
Andrea Wippermann

Contact
Lage Markt 3 (Waalkade 4)
6511 VK Nijmegen
The Netherlands
Telephone: +31 (0) 24 3229670
Fax: +31 (0) 24 3604688
Email: mail@marzee.nl
www.marzee.nl

Lucy Sarneel
Sentier de jardin – necklace
2007
38 × 25 × 5 cm
Zinc, antique fabric on rubber, nylon thread
Photo: Eric Knoote

Lucy Sarneel's work is primarily the result of two closely entwined trajectories: her development as a jewellery designer and the course of her personal life. It is evident from her work that her concerns often show up as themes: her materials, the world of flowers and plants, her personal life and the mundane things all around us. Her research into the possibilities of an initial idea takes place through hands-on experiments with the materials themselves.

Dorothea Prühl
Grosse Katzen (Big Cats) 2007
31×16×2.7 cm
Aluminium, steel
Photo: Helga Schulze-Brinkop

Dorothea Prühl's style
is articulated in a concise
yet expressive language:
surprisingly simple things,
bulky, sometimes angular;
powerful works, filled with
a distinct inherent beauty
that goes far beyond the
conventional beauty of
traditional jewellery.

Galerie Ra

Since Galerie Ra was opened by Paul Derrez in the centre of Amsterdam in 1976, its policy has focused primarily on promoting jewellery as an art form. Originality, quality and continuity are the starting-points for the gallery's exhibition programme, in which work from around 50 international artists is represented. Eight exhibitions a year are organised, chiefly solo displays, and sometimes a thematic or group show with an accompanying catalogue.

Staff
Paul Derrez
Willem Hoogstede
Floor Mommersteeg
Mathieu Obers
Miecke Oosterman

Artists represented
Gijs Bakker
Julie Blyfield
Sigurd Bronger
Johanna Dahm
Georg Dobler
Warwick Freeman
Karl Fritsch
Peter Hoogeboom
Marian Hosking
Susanne Klemm
Esther Knobel
Daniel Kruger
Bettina Speckner
Catherine Truman

Contact
Vijzelstraat 80
1017 HL Amsterdam
The Netherlands
Telephone: +31 (0) 20 6265100
Fax: +31 (0) 20 6204595
Email: mail@galerie-ra.nl
www.galerie-ra.nl

Catherine Truman
White Anatomy 1 and 2 – brooches 2007
Left: 9.5 × 7 × 1.2 cm
Right: 11.5 × 5.5 × 1.2 cm
Hand-carved English lime-wood, paint, sterling silver, stainless steel
Photo: Grant Hancock

'I draw my conceptual inspiration from a diverse range of sources – from the history of anatomy to the study of human movement. The resulting works, characteristically carved from wood, are not anatomical replicas but rather pieces that evoke a physical and sensory response. I am currently fascinated by the relationship between the artistic and scientific processes of imaging the human body, particularly the idiosyncratic slippages between the perfect and the imperfect body.'
Catherine Truman

Susanne Klemm
Frozen – necklace 2007
38 × 38 × 10 cm
Polyolefin (plastic),
thermo-formed
Photo: Harold Strak

'at my feet
when did you get here?
snail'
Translated by David G. Lanoue
(www.haikuguy.com)

'Like in this Japanese haiku
written in 1801 by Kobayashi
Issa, I express symbols of
seasons, human affairs and
flowers. They are personal
experience of moments in a
simplified and minimalist shape,
a thimble of emotions and
tribute to the beauty of nature.'
Susanne Klemm

Galerie Rob Koudijs

Galerie Rob Koudijs sprang from more than 25 years commitment to contemporary art-jewellery. The gallery presents established artists and emerging new talents via regular exhibitions. It shows sometimes autonomous works of art, mostly wearable pieces and in any case surprising, innovative jewellery of the highest standard.

Staff
Rob Koudijs
Ward Schrijver

Artists represented
Frédéric Braham
Sebastian Buescher
Gemma Draper
Jantje Fleischhut
Felieke van der Leest
Javier Moreno Frías
Ted Noten
Mary Preston
Natalya Pinchuk
Katja Prins
Roos van Soest

Contact
Elandsgracht 12
1016 TV Amsterdam
The Netherlands
Telephone: +31 (0) 20 331 87 96
Mobile: +31 (0) 6 139 05 554
Email: info@galerierobkoudijs.nl
www.galerierobkoudijs.nl

Katja Prins
Continuum – brooch 2007
7.4 × 6.2 × 2.3 cm
Silver, sealing-wax
Photo: Francis Willemstijn

Dutch artist Katja Prins is intrigued by the connections between the human body and the ever increasing possibilities of modern technology. In her jewellery she has a longstanding reputation for applying unconventional materials charged with strong connotations. In the *Continuum* pieces she uses the expressive potential of classic sealing-wax to dwell upon the interaction between medicine and man. Without passing easy judgements, these brooches are tempting objects, which combine an unidentifiable uneasiness with sheer beauty.

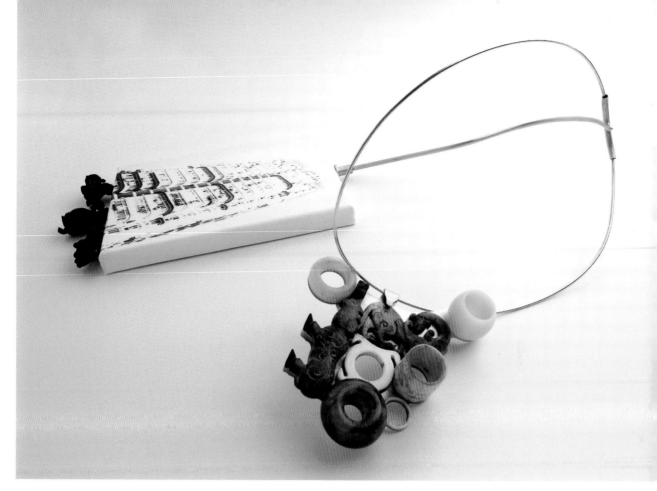

Ted Noten
Beijing – necklace 2006
Top: 10 × 15 × 2 cm
Bottom: 12 × 15 × 2.5 cm
Diameter: 35 cm
Silver gilt, antique ready-mades, canvas
Photo: Ted Noten

Ted Noten combines his wit and sharp eye with refined craft techniques and state-of-the-art technology, making him one of the world's leading jewellery artists from the Netherlands. Using the world as his workshop, he travelled from Japan to Amsterdam on the Trans-Siberian Express collecting impressions and objects at every stop on the way. It resulted in monumental objects built on the vernacular of jewellery, which make audible the clash between a rich heritage and contemporary life.

86

Galerie
Rosemarie Jaeger

'It's an unconventional place…'

Staff
Rosemarie Jaeger

Artists represented
Otto Baier, Metal
Rudolf Bott, Jewellery/Metal
Bettina Dittlmann, Jewellery
Michael Jank, Jewellery
Christa Luehtje, Jewellery
Annamaria Zanella, Jewellery

Contact
Wintergasse 13
65239 Hochheim, Germany
Telephone: +49 (0) 6146 2203
Fax: +49 (0) 6146 601068
Email: galerie-r.jaeger@
t-online.de
www.rosemarie-jaeger.de

Bettina Dittlmann
Untitled – brooch 2005
8 × 8 × 7 cm
Iron wire, garnet
Photo: Michael Jank

'Dealing with the stone. How
to hold it. How to treasure
it. By thinking and working,
the bezel started a life on
its own…'
Bettina Dittlemann

Rudolf Bott
Ansteckschmuck 1996
10.5 × 6 × 3 cm
Gold 750/ooo
Photo: Jochen Grün

'Thoughtful and steady, reliable
and exact, powerful and solid,
unflagging and surprising,
circumspect and full of
imagination… That's the way
Rudolf Bott, is, lives and works.'
Jo and Herman Jünger

Galerie S O

Galerie S O, located in the old baroque Swiss city of Solothurn, is a space for a creative interchange between makers and users on a national and international level. Galerie S O's aim is to raise the public's perception and understanding of the concepts and processes applied by artists and makers, and how these influence and inform their creative output in the field of contemporary jewellery, metalwork and objects.

Staff
Felix Flury

Artists represented
Peter Bauhuis, Metal/Jewellery
David Clarke, Metal
Christian Gonzenbach, Ceramics
Andi Gut, Jewellery
Manon van Kouswijk, Metal/
Ceramics
Bernhard Schobinger, Jewellery
Verena Sieber-Fuchs, Jewellery
Hans Stofer, Metal/Jewellery/
Ceramics
Simone ten Hompel, Metal
Lisa Walker, Jewellery

Contact
Riedholzplatz 18
CH-4500 Solothurn, Switzerland
Telephone: +41 (0) 32 623 35 44
Fax: +41 (0) 32 623 35 44
Email: info@galerieso.com
www.galerieso.com

Lisa Walker
Untitled – necklace 2007
Height 24 cm, width 20 cm
Sticky-tape
Photo: Lisa Walker

'I have started ignoring the direction a material may naturally push me in. I'm being less respectful.' Perhaps I should start making sculpture? Nah, I'm too lazy and don't have enough time – too much work researching all that sculpture history and stuff – jewellery is enough.'
Lisa Walker

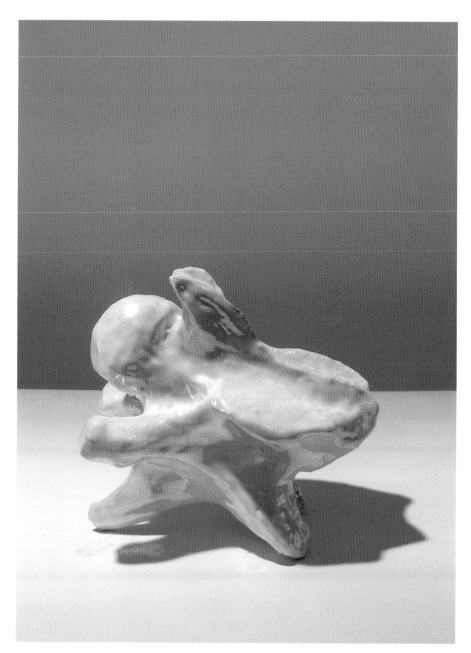

Christian Gonzenbach
Girafe 2007
24 × 24 × 16 cm
Ceramic
Photo: Felix Flury

'My entire work is based
around the floating notion
of day-to-day life and its
extraordinary banality. My aim
is to arouse attention by using
only well-known things, but in
uncommon ways. I am tracking
the things that go unnoticed
in our life. Food and everyday
objects are my field of action.'
Christian Gonzenbach

Galerie Sofie Lachaert

Galerie Sofie Lachaert brings exhibitions of international jewellers and object-makers. In addition there is a ever-changing permanent collection. Quiet, authenticity, reflection and a warm atmosphere can be found in this larger space within the remains of an old shipyard.

Staff
Luc d'Hanis
Sofie Lachaert

Artists represented
Giampaolo Babetto, Jewellery/Metal
Annemie De Corte, Jewellery/Metal
Anna Heindl, Jewellery
Thalia Georgoulis, Metal
Salima Thakker, Jewellery
Anna Torfs, Glass

Contact
St Jozefstraat 30
B 9140 Tielrode, Belgium

Zwartezustersstraat 20
B 9000 Gent, Belgium

Telephone: +32 (0) 3 711 19 63
Email: info@lachaert.com
www.lachaert.com

Giampaolo Babetto
Brooch 2007
9.1 × 7 × 1.5 cm
Yellow gold 750, pigment
Photo: Giustino Chemello

Giampaolo Babetto uses pure, geometrical forms in his jewellery. They become alive through the sensitivity of the material, the gold and the pigments. His silverware has the same qualities: beautiful, minimal forms, perfect dimensions. But their delicate skin still shows traces of the chasing hammer, the rim is frayed, left unfinished, giving the sober pieces a poetic quality, emphasising their quiet sensuality.

Anna Heindl
Eyes of the Horse – collier 2006
30 × 7 × 3.5 cm
8-carat gold, stainless steel,
black pearls
Photo: Manfred Wakolbinger

Anna Heindl's pieces of
jewellery clearly show her
preference for the unusual,
striking combinations of
material, shapes and colours.
Yet her work is beautifully
harmonious. And wearable.
It tells us about her sources of
inspiration, reflects the themes
that fascinate her – nature, art.

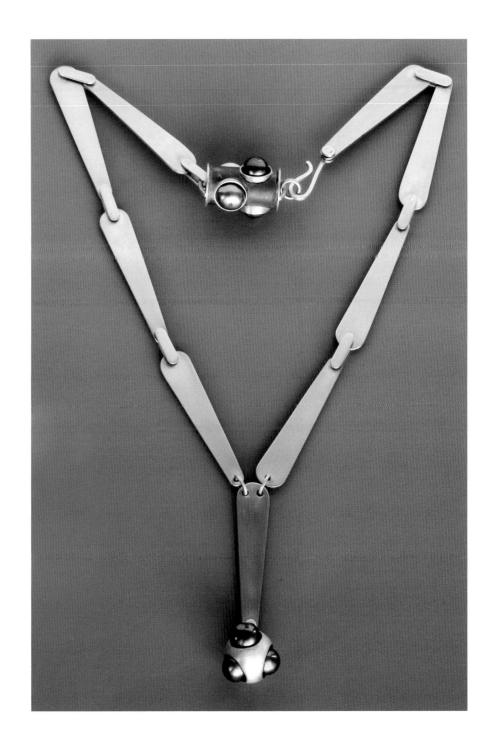

Galerie Terra Delft

Galerie Terra Delft, founded in 1986, is a gallery for contemporary ceramics. In addition to exhibitions featuring both Dutch and foreign ceramicists, the gallery also serves as a permanent sales point.

Staff
Joke Doedens, Director
Simone Haak, Director

Artists represented
Wim Borst
Heather Park
Carolein Smit
Henk Wolvers
Yuk Kan Yeung

Contact
Nieuwstraat 7
2611 HK Delft, The Netherlands
Telephone: +31 (0) 15 2147072
Fax: +31 (0) 15 2147072
Email: info@terra-delft.nl
www.terra-delft.nl

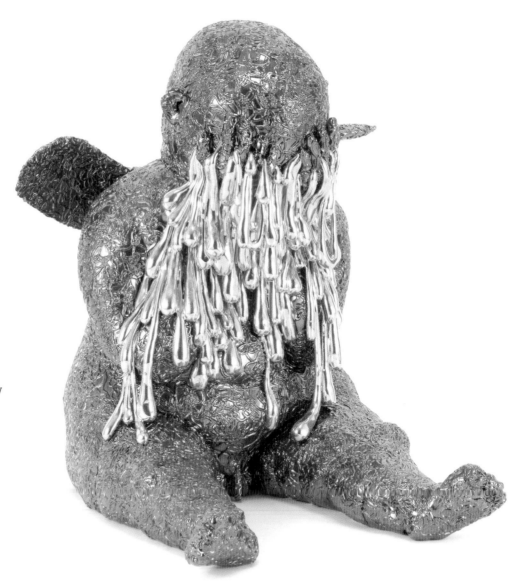

Carolein Smit
Angel with Tears 2007
60 × 45 × 50 cm
Ceramic
Photo: Winnifred Limburg

There is something otherworldly about Carolein Smit's ceramics, especially her all-white sculptures and her many figures that appear to be hiding under their long hair. The creatures and people she depicts often convey a sense of desperation, frequently gripping their heads with their hands, or suffering in some way: a rodent in a teacup, a sheep with its legs bound, a small angel with its fingers in its mouth as if hungry or afraid.

Wim Borst
Partition Series 3 2007
30 × 33 × 21 cm
Ceramic
Photo: Wim Borst

Wim Borst's ceramics have
their roots in the Dutch
geometrical-abstract tradition,
although he uses the idiom
in a non-academic, refreshing
way. Within the boundaries of
geometric abstraction, he takes
liberties with colours, materials
and themes. His objects are
generally made up of different
parts. Besides the perfect
geometrical form, the treatment
of the material is of great
importance to him.

Galleria Norsu

Galleria Norsu concentrates on the finest in innovative Nordic applied art, both sculptural and functional, including jewellery, ceramics, textiles, wood and glassware.

Staff
Saara Kaatra
Eva Persson
Katarina Siltavuori

Artists represented
Erna Aaltonen, Ceramics
Mervi Kurvinen, Jewellery
Kati Nulpponen, Jewellery
Maria Nuutinen, Jewellery
Pekka Paikkari, Ceramics
Kristina Riska, Ceramics
Kim Simonsson, Ceramics
Caroline Slotte, Ceramics

Contact
Kaisaniemenkatu 9
PO Box 152
FI-00171 Helsinki, Finland
Telephone: +358 (0) 9 2316 3250
Email: galleria@norsu.info
www.norsu.info

Pekka Paikkari
Sheet 2007
50 × 50 cm
Ceramic
Photo: Pekka Paikkari

'For me, human presence is the starting-point of art. Clay is a flexible material for expression and as such contains the history of time. As an artist I construct a never-ending story. Despite the physical appearance of the art work, whether it is placed on the façade of a building or is an installation consisting of several pieces, the dialogue between the viewer and the work defines its final form.'
Pekka Paikkari

Kim Simonsson
Steel Rabbit 2007
110 × 100 × 145 cm
Ceramic, glass, platinum, bondo
Photo: Kim Simonsson

'I made my first sculpture out of snow in the backyard of my childhood home. I realised then that I can capture the sensitiveness of movement through my hands. Ever since I have thought of myself as a sculptor who makes figures by hand. Finding the perfect movement has become the essence of my work. I combine traditional ceramic art with popular cultural phenomenon in my large ceramic sculptures. For me the unusual is interesting. Therefore I create my own strange world of characters that comment on everyday life and its weirdness. The subject-matters are usually children, animals or hybrids. An important detail in my sculptures are the eyes made out of glass that give the figures a lifelike appearance. Authority in its many forms fascinates me, and in my works I want to reverse common belief by making the weak powerful.'
Kim Simonsson

Galleri Format

Galleri Format is located in Norway, in the cities of Oslo and Bergen, and represents over 350 artists. All of the artists are handpicked by a jury, which guarantees the high quality of the works of art. The owner of the gallery is The Norwegian Association for Arts and Crafts.

Staff
Stine Tveten, Assistant Director
Heidi Bjørgan, Assistant
Martina Kaufmann, Project Leader

Artists represented
Marit Helen Akslen, Textiles
Ulla-Mari Brantenberg, Glass
Lillian Dahle, Wood
Tulla Elieson, Ceramics
Kari Brovold Hagen, Ceramics
Konrad Mehus, Jewellery
Ingrid Nord, Glass
Ansgar Ole Olsen, Metal
John Kåre Raustein, Textiles
Heidi Sand, Metal
Lise Schönberg, Jewellery

Contact
Rådhusgate 24
N-0151 Oslo, Norway
Telephone: +47 22 41 45 40
Fax: +47 22 01 55 71
Email:oslo@format.no
www.format.no

Vågsalmenningen 12
N-5014 Bergen, Norway
Telephone: +47 55 30 48 90
Fax: +47 55 30 48 99
Email: bergen@format.no
www.format.no

Heidi Sand
Rotate Necklace 2006
Diameter 9 cm
Silver
Photo: Sveinung Bråthen

Rotate Necklace is one of a series of pieces where the intention is to investigate interactions between layered patterns. Artistic expression is conveyed through the construction of patterns from simple geometric forms, creating rhythm and contrast. Multi-layered works give rise to new patterns, and movement produces optical effects. The pieces can either be worn as jewellery or be attached to a motor mounted to a wall.

Ansgar Ole Olsen
Proletarian Prominence 1999
80 × 160 × 60 cm
Steel, varnished with car paint
Photo: Ansgar Ole Olsen

'In this piece I mainly wanted to focus on the political development of the working class in recent years. Increasing prosperity and the swing to the right have also swept over traditional working-class bastions. This wheelbarrow can say something about the relationship between roots – origins – and the flight from them. The car paint on the surface is so highly polished that anyone looking closely will also see his/her own reflection and may ask some questions about his/her own place in the machinery of society.'
Ansgar Ole Olsen

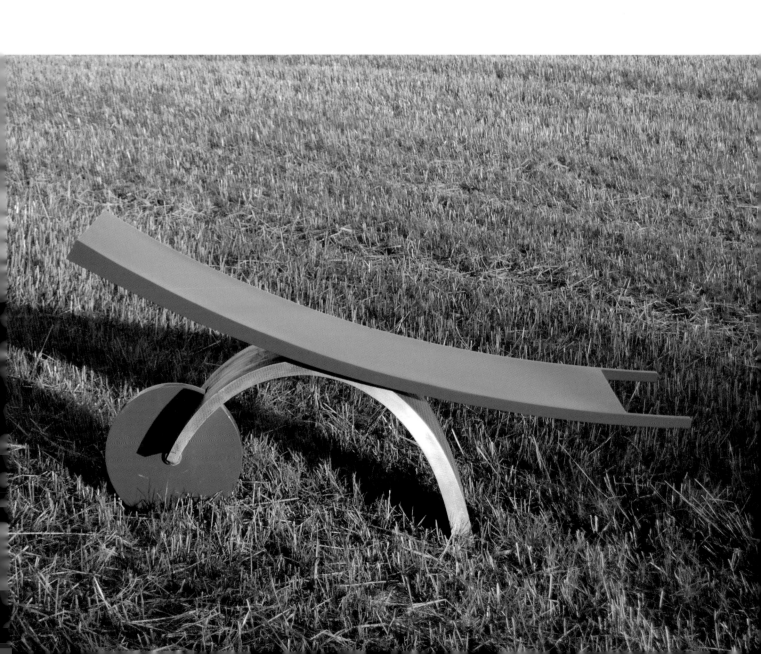

Galleri Montan

Galleri Montan is the leading gallery in Denmark for contemporary silverwork. Work from prominent Danish and international silversmiths is on display at this permanent base. The silversmiths' solid background in silversmithing and their use of their imagination, combined with their cultural heritage, enable the production of stunning works of art in silver, which is apparent in the work on display in the gallery.

Staff
Lasse Montan, Owner
Claus Andersen, Director

Artists represented
Carsten From Andersen
Claus Bjerring
Gitte Bjørn
Ane Christensen
Sidsel Dorph-Jensen
Else Nicolai Hansen
Leon Kastbjerg Nielsen
Allan Scharff
Pétur Tryggvi

Contact
Bredgade 10
1260 Copenhagen K, Denmark
Telephone: +45 3537 0068
Fax: +45 3537 0068
Email: montan@montan.dk
www.montan.dk

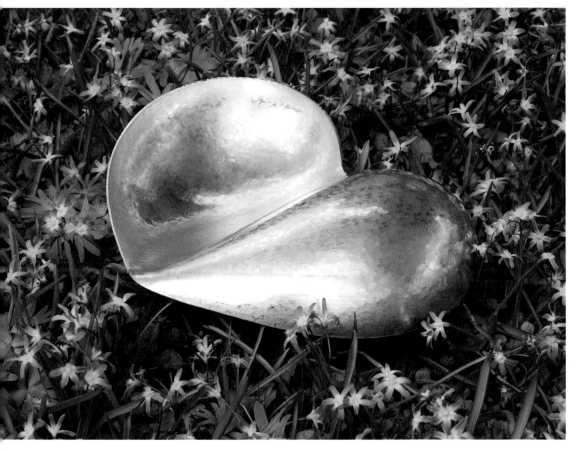

Allan Scharff
Half-Hearted 2006
8 × 32 × 32 cm
999 fine silver
Photo: Miklos Szabo

'The half-hearted bowl is my ironically, but fully functional comment on the speedy shallowness of our times. Created to be placed on the coffee table, kindly reminding us how roomy our heart really is. Two-sided.'
Allan Scharff

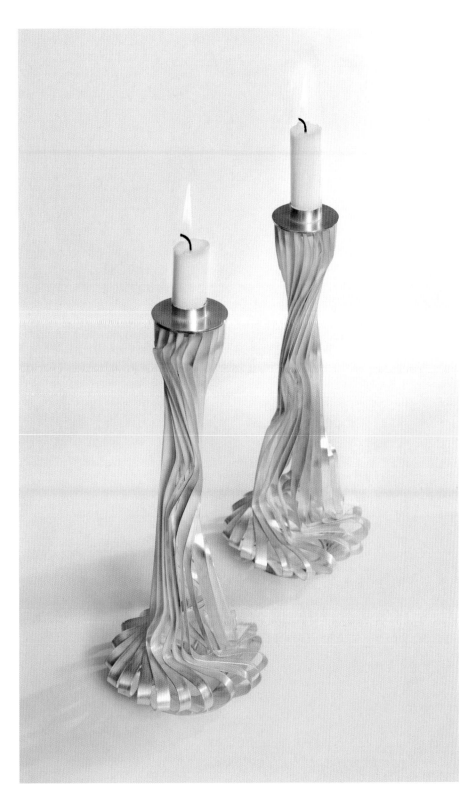

Sidsel Dorph-Jensen
Candelabra 2007
30 × 12 × 12 cm
958 Britannia silver
Photo: Camilla Hey

'I enjoy exploring silver's
properties, its malleability in
complex constructions, and
have in my new, layered pieces
used traditional silversmithing
techniques to create volume
and spaces. I find it quite
important to show my process
in the finished piece, as the
making stages are when silver
is most precious to me. In the
candelabras I have explored
how fluidity, movement and
volume can be created in the
repetition of a simple line.'
Sidsel Dorph-Jensen

The Gallery, Ruthin Craft Centre

Long established as Wales's premier gallery for generating monograph and survey exhibitions by artists from Wales and abroad. As our new galleries and centre are under development, this year's Collect offers a window into our future programme that premières exciting new work.

Staff
Philip Hughes, Director
Jane Gerrard, Deputy Director

Artists represented
Michael Brennand-Wood, Textiles
Lucy Casson, Mixed Media
David Colwell, Furniture
Claire Curneen, Ceramics
Michael Flynn, Ceramics
Eleanor Glover, Mixed Media
Catrin Howell, Ceramics
Christine Jones, Ceramics
Walter Keeler, Ceramics
Andrew Logan, Mixed Media
Eleri Mills, Textiles
Pamela Rawnsley, Metal
Audrey Walker, Textiles

Contact
Park Road, Ruthin
Denbighshire, LL15 1BB
North Wales, UK
Telephone: +44 (0) 1824 704774
Fax: +44 (0) 1824 702060
Email: thegallery@rccentre.org.uk
www.ruthincraftcentre.org.uk

Michael Flynn
Acrobats with Dark Glasses
2005
Height 56 cm
Faience
Photo: Michael Flynn

'Flynn's work has its own theatricality. The acrobatic actions are larger than life, groups form tableaux, stories are being told and metaphors abound. As in a Mozart opera, their gaiety has melancholy undercurrents, their propriety is besieged by unruly desire. Are these turbulent ceramic figures that grapple and tumble around each other engaged in playful tickling, sexual games or a battle to the death? Are they characters from myth or ordinary mortals?'
Judy Dames (*Collecting Contemporary Ceramics*, 2006)

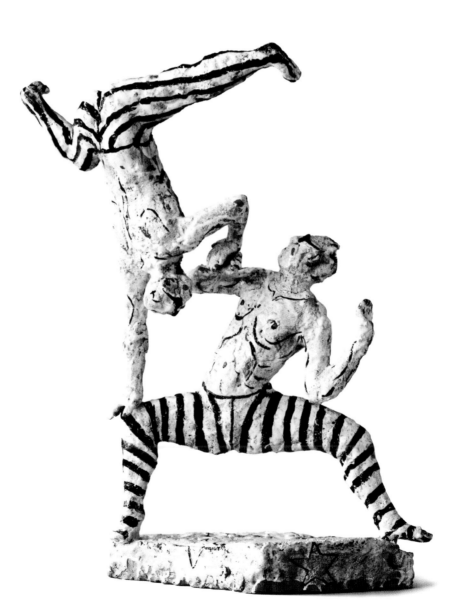

Pamela Rawnsley
Four Visits – vessel sequence
2007
12 × 44 × 4.3 cm
Silver, oxide with gold detail
Photo: Keith Leighton

Pamela Rawnsley's constructed silver vessels are a direct response to the landscape of mid-Wales. In her most recent work the shape-shifting rhythms and patterns of light, line and atmosphere, are translated into lyrical sequences of vessels. These may be quiet, reflective or exuberant, but always carry multiple layers of resonance and meaning. Her work is now represented by several national collections.

Eleanor Glover
A Close Examination 2005
49 × 24 × 24 cm
Wood, aluminium, cardboard,
gold leaf
Photo: Dewi Tannatt Lloyd

'Eleanor is a storyteller. Her
work stays in our thoughts
because… it connects with
our emotions and memories,
with the human condition. Care
and tenderness are apparent
through the gently carved
and sanded wood figures,
the expressive hands and the
hovering birds. The skills that
she uses when handling
materials achieve an intensity
of feeling with a lightness of
touch in the physical object.
Eleanor works with intelligence
to create simple forms that are
calm but edgy with life.'
Mary La Trobe-Bateman
(*Eleanor Glover*, 2006)

Michael Brennand-Wood
Flower Head – Narcissistic Butterfly 2005
Height 40 cm, diameter 60 cm
Machine-embroidered flowers, mirror, piano wire, photographic faces, beads, fabric, acrylic paint
Photo: Peter Mennim

Michael Brennand-Wood is internationally regarded as one of the most innovative and inspiring artists working in textiles. Michael has explored and developed his own techniques, inventing many new and imaginative ways of integrating textiles with other media. Recent works, inspired by traditions of floral imagery, have utilised computerised machine embroidery, acrylic paint, wood, glass and collage. Exploring the illusionary space between two and three dimensions, these works are colourful, dramatic, rhythmic and holographic in feel.

Glass Artists' Gallery

Since 1982, the Glass Artists' Gallery has been Australia's foremost showcase for contemporary glass. It has played a major role in the promotion of exceptional work by emerging and established artists, making it an ideal gallery for the collector. It was established by Maureen Cahill, a seminal figure in the Australian Glass Movement and co-founder of the Ranamok Prize for Contemporary Glass.

Staff
Maureen Cahill, Director

Artists represented
Nicole Ayliffe
Tali Dalton
Jasper Dowding
Tevita Havea
Daniela Turrin

Contact
70 Glebe Point Road, Glebe 2037
Sydney, NSW, Australia
Telephone: +61 (0) 2 9552 1552
Fax: +61 (0) 2 9552 1552
Email:
mail@glassartistsgallery.com.au
www.glassartistsgallery.com.au

Nicole Ayliffe
*Optical Landscape –
Sand Dune* 2007
34 × 20 × 7 cm
Hot-blown glass, gel medium
photographic image
Photo: Michal Kluvanek

The optical qualities of glass serve as an ongoing foundation for development within the *Optical Landscape* series. The thickness of the form gives the illusion of space, creating an optical lens, while the curved surfaces create an illusion of movement, depth and distortion. The black and white photographic images reference the Australian landscape and are highlighted by the refraction of light through the glass form.

Tevita Havea
Pulotu 2007
20 × 83 × 16 cm
Glass, wood, twine, hair: blown,
sandblasted, woven
Photo: Stuart Hay

'The more I entangle the
materials, the more I unravel
inside. The abstract forms
are my symbolic response
to the mysteries of life, death
and the hereafter. I like what
Jung said about the collective
unconscious that we inherit
at birth (from the very first
human), ancient symbols that
we are drawn to because they
represent something profound
within us that we have always
known but have long forgotten.'
Tevita Havea

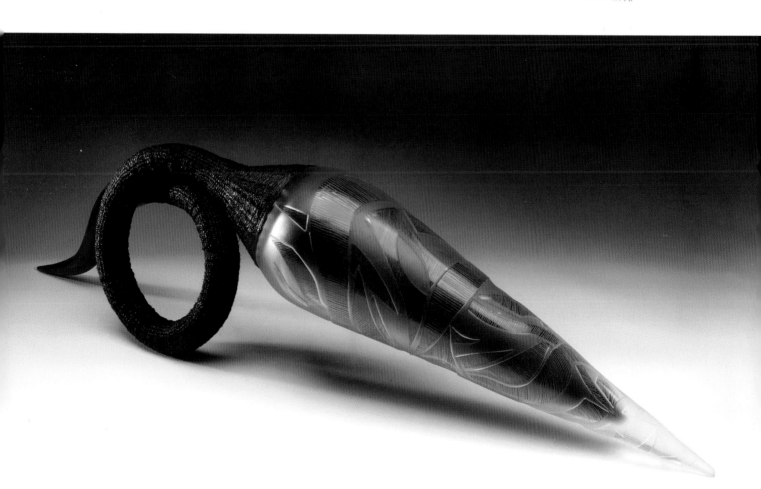

The Glassery

The Glassery is a new forum for glass in Sweden. Our intention is to create an exciting platform for our artists internationally. We work with the most interesting, young and independent glass artists of today.

Staff
Patrick Hällbom, Director

Artists represented
Esmé Alexander
Jonas Rooth
Hanna Stahle
Claes Uvesten

Contact
Gallery: Ragvaldsgatan 17
Södermalm, Sweden
Enquires: Sankt Paulsgatan 11
11846 Stockholm, Sweden
Telephone: +46 (0) 8 25 11 95
Email: info@theglassery.se
www.theglassery.se

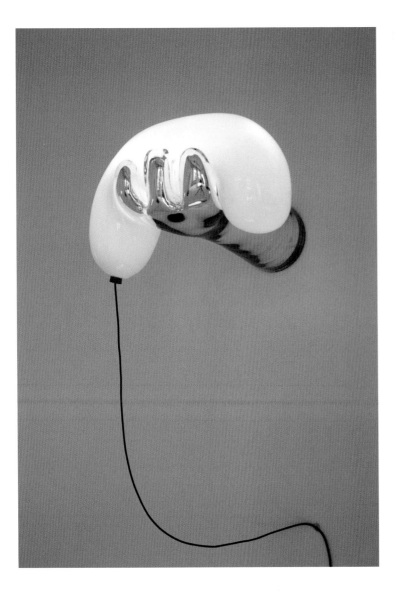

Hanna Stahle
Pleased 2006 (one of seven variants)
15 × 25 × 30 cm
Glass, partly silver foliated, LED light
Photo: Hanna Stahle

'I try to give my artworks an atmosphere that is loaded with light, with a content that never is intended to be unambiguous and therefore hopefully will give more than one association and interpretation. Gloves and hands are two symbols that constantly recur to me. It interests me that they can represent a lot of different, and sometimes even opposite things, such as dissociation, care, responsibility and power.'
Hanna Stahle

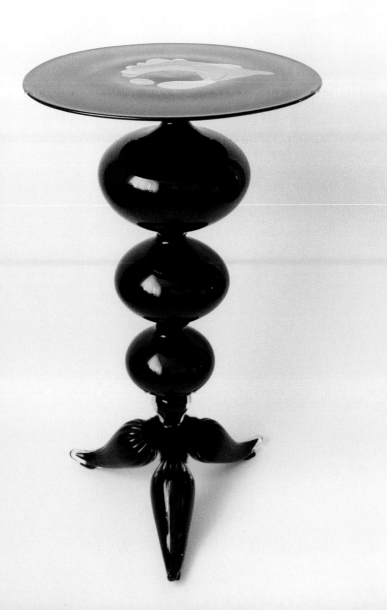

Esmé Alexander
For Alice 2006
95 × 50 × 50 cm
Hand-blown glass, lacquer,
mink fur
Photo: Esmé Alexander

'Esmé Alexander's glass is the
art of absurdity, where running
and dripping paint, hues of
pastel, drops of glass create
the unexpected, and where
every object is a witness of
the dynamical dance before
its own completion.'
Peter Öhrlen
(*Konsthantverkaren*, 1, 2007)

'*For Alice* is a homage as well
as an imaginary meeting place,
a possibility to sit down and
chat with the cat, the rabbit and
Alice herself.'
Esmé Alexander

Guil-Guem Metal Arts Research Centre

Since 1995, Guil-Guem Metal Arts Research Centre has specialised in Korean metal arts, mostly craft-based pieces and jewellery. Our focus is on 'Ipsa', a unique and highly challenging Korean damascene technique. Jung-Sil Hong, officially named as the master of Ipsa by the Korean government, is the founder and leader of our centre. In addition to honing our skills and training new artists, our ultimate vision is to revive old Korean arts and crafts in the present.

Staff
Jung-Sil Hong, Director
Moon-Jung Kim, Assistant Director
Sun-Jung Kim, Assistant Director

Artists represented
Jung-Sil Hong, Media

Contact
#403 Centre for training in Important Intangible Cultural Properties
112–2 Samsung-dong
Gangnam-gu
Seoul 135–090, South Korea
Telephone: +82 (0) 2 556 5376
Fax. +82 (0) 2 556 5395
Email: ipsa78@hotmail.com
www.guilguemcraft.org

Jung-Sil Hong
Spiritual Wave 2005
38 × 37 × 37 cm
24-carat gold, silver, copper, steel, mother-of-pearl
Photo: H. M. Hwang

'Through the use of the Ipsa, this work expresses the psychological realm that abides within me (such as countless feelings or certain insights that emerge from my sub-consciousness). It depicts the "wave of life", awakened from deep within me through my experiences in the endlessly continuing timeline in which we live. Its form, as either a sculptural object or vessel, is rooted in the traditional Korean vessel form.'
Jung-Sil Hong

Jung-Sil Hong
Meditation 2005
39 × 16 × 16 cm
Silver, cupro-nickel, steel,
mother-of-pearl
Photo: H. M. Hwang

'This work embraces nostalgia
for beauty, including such
concepts as "purity/pureness"
and "nature", for which I have
always longed. Revealing the
loss of function through a
bottomless form, it confronts
the "wobbly" minds of people
and the materialism and cold,
technological world in which
we live – yet, it draws upon an
endless affection for things that
are non-materialistic and will
ultimately vanish for ever.'
Jung-Sil Hong

Joanna Bird Pottery

Joanna Bird Pottery shows work from British and Japanese contemporary studio ceramicists drawn from the traditional and unusual. Grass-roots masters are also included to give historical perspective and to inspire.

Staff
Joanna Bird, Owner
Helen Beard, Assistant
George Bird, Assistant
Carina Ciscato, Assistant
Margerita Mariani, Assistant

Artists represented
Richard Batterham
Helen Beard
Clive Bowen
Michael Cardew (1901–83)
Fernando Casasempere
Carina Ciscato
Hans Coper (1920–81)
Daniel Fisher
Fukami Sueharu
Hamada Shoji (1894–1978)
Hayashi Yasuo
Bernard Leach (1887–1979)
Imura Toshimi

Kohara Yasuhiro
John Maltby
Miyazawa Akira
Morino Hiroaki Taimei
Lucie Rie (1902–95)
Suleyman Saba
Tatebayashi Kaori
Tsuboi Asuka
Annie Turner

Contact
By appointment:
19 Grove Park Terrace, Chiswick
London, W4 3QE, UK
Telephone: +44 (0) 20 8995 9960
Fax: +44 (0) 20 8742 7752
Email: Joanna.bird@btinternet.com
www.joannabirdpottery.com

Helen Beard
Cold Faces and Red Noses at Somerset House 2006
Height 16 cm, Diameter 36 cm,
Hand-thrown and decorated porcelain
Photo: Cesca Simms

'Working with a Limoges porcelain, I throw a simple, white ceramic form, on to which I put a drawing. The technique for drawing is my own researched method of relief print and colour wash. Each individual pot has an illustration, a scene from the way we live. I follow themes that are often nostalgic or even old fashioned. The pots tell a story, sometimes quirky, often with a touch of humour about the British way of life.'
Helen Beard

Tsuboi Asuka
Morning in Kyoto 2005
57 × 29 × 30.5 cm
Hand built with Shigaraki clay,
multiple glazed with gold and
silver enamels
Photo: Alexandra Negoita

'I am fascinated by cloth
and paper. I feel as though
our joys and sorrows – the
patterns of human life – are
all revealed there.'
Tsuboi Asuka uses clay to
portray the softness and grace
of Kyoto textiles.

Katie Jones

Katie Jones represents contemporary artists from Japan. While the artists chosen have a thoroughly modern outlook, they retain that indefinable Japanese aesthetic.

Staff
Katie Jones, Director
Lesley Mallyon, Assistant

Artists represented
Shihoko Fukumoto, Textiles
Koji Hatakeyama, Metal
Hiroki Iwata, Metal
Toru Kaneko, Metal
Tsubusa Kato, Ceramics
Eiko Kishi, Ceramics
Ritsue Mishima, Glass
Takeshi Mitsumoto, Metal
Takayuki Sakiyama, Ceramic
Shinya Yamamura, Lacquer

Contact
68 Elgin Mansions, Elgin Avenue
London, W9 1JN, UK
Telephone: +44 (0) 20 7289 1855
Fax: +44 (0) 20 7289 1855
Email: kjoriental@lineone.net
www.katiejonesjapan.com

Eiko Kishi
Saiseki Zogan Vase 2006
28 × 23 × 23 cm
Ceramic
Photo: Eiko Kishi

'I create my work using a technique I have called Saiseki Zogan or coloured-stone inlay. In my original technique I use clay with coloured grog mixed in to create my forms. Then I bring various colours out by finely carving the surface of the work. I believe rather than simply imitating natural forms, abstract expressive forms are more appropriate for my work. My present works are based on images from Noh theatre: costumes, dance movements, the stage and the music. I believe that works of art should exist in a realm beyond daily life. My works are personal, and I hope to make them expressions of my total self.'
Eiko Kishi

Koji Hatakeyama
Polygon Shaped 2007
18 × 21.5 × 21.5 cm
Patinated cast bronze, gold leaf
Photo: Koji Hatakeyama

The Consciousness of Bronze

Bronze has a will to wear rust,
To protect the body on its own.

Thinking of that,
I feel a desire to have such a will of bronze
Obstinately trying to protect the self.
I am deeply conscious of my attempt,
To touch "whatever" lies deep in the spirit and
 the material.

Then bronze makes
"Whatever" that lurks
Emerge as something visible.
It begins to wear rust's will,
Leaving somewhere the distance between myself
 and an object,
The relationship between the internal and the
 outside spaces,
And all indications of being bronze,
As well as my consciousness.

Koji Hatakeyama

Konsthantverkarna

Konsthantverkarna was formed in 1951 and is today the largest co-operative of professional craftsmen in Sweden. We promote and market Swedish crafts of the highest quality, which, from inception to execution, display a dynamic relationship to our immediate surroundings and beyond.

Staff
Sarah Hurni-Åsberg, Manager
Peter Nylander, Sales

Artists represented
Carina Seth Anderson, Glass
Agneta Linton, Glass
Åsa Lockner, Metal
Mårten Medbo, Ceramics
Jussi Ojala, Ceramics
Åsa Pärson, Textiles
Tore Svensson, Metal
Pasi Välimaa, Textiles

Contact
Södermalmstorg 4
116 45 Stockholm, Sweden
Telephone: +46 (0) 8 611 03 70
Fax: +46 (0) 8 641 58 95
Email: info@konsthantverkarna.se
www.konsthantverkarna.se

Åsa Lockner
Kulbrosch 2005
8 × 7 × 1 cm
Silver, moss agate
Photo: Mats Håkanson

'The ephemeral nature of life is both beautiful and liberating and stands in contrast to my preferred working materials. Impermanence expressed in metal and stone. Each piece I produce is part of a complex equation of emotion, inspiration and material that is the constantly changing presence of my workshop. The challenge lies in incorporating the correct amount of myself into this equation in order to direct but not dictate the results.'
Åsa Lockner

Mårten Medbo
Velvet 2006
14 × 23 × 44 cm
Stoneware
Photo: Mårten Medbo

'I am driven by curiosity.
My curiosity over materials
concerns the limitations of
their workability; to some
extent this is the greatest
challenge a material has
to offer. Artistically my work
revolves around ideas of
ugliness and beauty. When
does the disgusting and
repellent evolve into the
desirable and pleasant?
Prompting the questions, how
does one's own experience
influence these judgements,
and how they are made?'
Mårten Medbo

Lesley Craze Gallery

Lesley Craze Gallery is an internationally recognised showcase for contemporary jewellery, metalwork and textiles. Our collections encompass work from 100 highly skilled and talented artists from around the world. The gallery has an innovative events programme with exhibitions showcasing the work of emerging talent, highlighting the excellence of established designers or examining various techniques and materials.

Staff
Lesley Craze, Managing Director
Rebecca Sweeting, Manager

Artists represented
Michael Becker, Jewellery
Nora Fok, Jewellery
David Goodwin, Jewellery
Jo Hayes-Ward, Jewellery
Yasuki Hiramatsu,
Jewellery/Metal
Magie Hollingworth, Paper
Yoko Izawa, Jewellery
Daphne Krinos, Jewellery
Hanneke Paumen,
Jewellery/Textiles
Angela O'Kelly, Jewellery
Michihiro Sato, Jewellery
Sachiyo Sharma, Textiles
Georgia Wiseman, Jewellery

Contact
33–35a Clerkenwell Green
London, EC1R 0DU, UK
Telephone: +44 (0) 20 7608 0393
Fax: +44 (0) 20 7251 5655
Email: info@
lesleycrazegallery.co.uk
www.lesleycrazegallery.co.uk

Daphne Krinos
Brooch 2007
6.5 × 7.5 × 0.5 cm
18-carat gold, beryl
Photo: Joël Degen

'I am inspired by the shapes and colours of the precious stones that I work with. They are the starting point for the pieces; pale and delicate in appearance and translucent in nature. I then "frame" them as if trying to protect them, using my sketches from geometric structures such as cranes, building sites and protective fences.'
Daphne Krinos

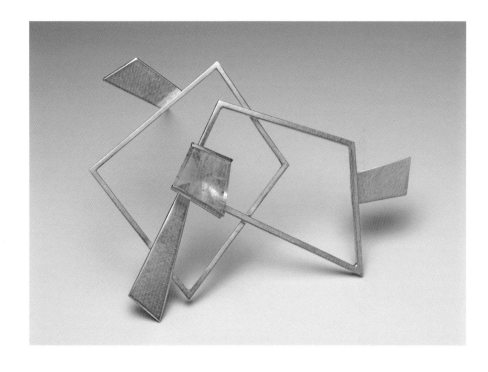

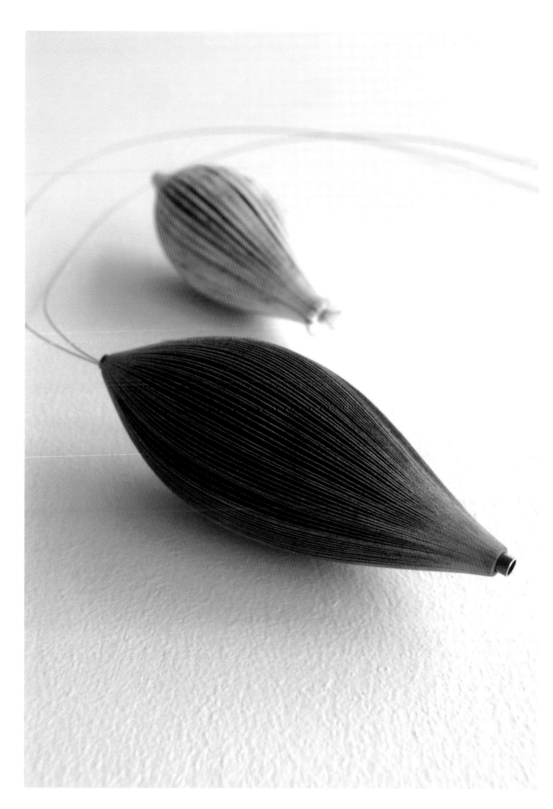

Michihiro Sato
Seed 2007
4.5 × 12.5 × 4.5 cm
Paper, silver, brass
Photo: Michihiro Sato

'The Chinese character "種" means not only "seed" but also "variety". In the Lotus Sutra [a great Buddhist scripture] there is a sentence "種種説法". It reveals how Buddha preaches that one's awakening can be affected by the use of various figures of speech, depending on the individual situation. My work is inspired by the concept of "seed". Seed, implies cool courage and warm mercy.'
Michihiro Sato

Plateaux Gallery

Established since 1997, Plateaux Gallery specialises in showing the applied arts, with a particular emphasis on glass.

Staff
Leo Duval, Director
Chris Biddle
Graham Coombs-Hoar

Artists represented
Alex Anagnostou, Glass
Nicole Chesney, Glass
Jan Frydrych, Glass
Tomas Hlavička, Glass
Jon Kuhn, Glass
Oliver Lesso, Glass

Contact
1A Copper Row
Tower Bridge Piazza
Butlers Wharf
London, SE1 2LH, UK
Telephone: +44 (0) 20 7357 6880
Fax: +44 (0) 20 7357 6880
Email: gallery@plateaux.co.uk
www.plateaux.co.uk

Alex Anagnostou
Ovoid (V) in Red 2006
19 × 38 × 15 cm
Blown glass, hot worked,
glass threads, aluminium
Photo: Alex Anagnostou

'My own fascination with human nature and how we interact within our social and physical environment is the source of my inspiration. I use glass to capture and communicate the interconnections that we cannot always see. I believe that each action creates a reaction. The systems within our bodies are mirrors of the earth with rivers that flow with blood, while weblike communication systems passed on as cells divide and multiply, reflect larger views of galaxies and the cosmos. I enjoy working with analogies that relate to micro and macro concepts in our own interactions with each other.'
Alex Anagnostou

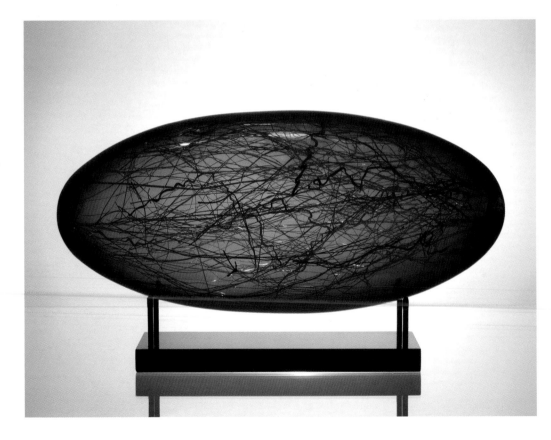

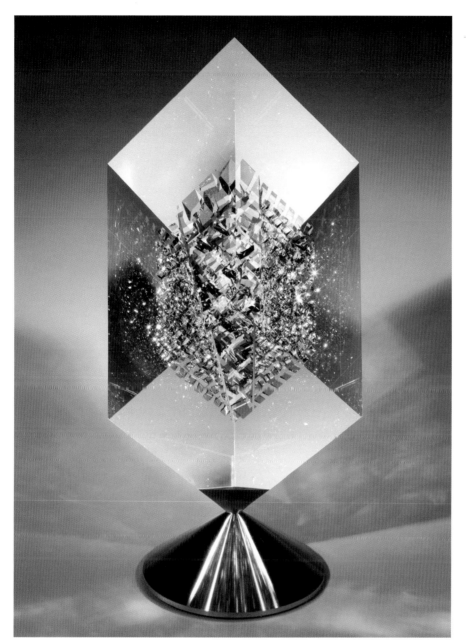

Jon Kuhn
Mirrored Ice 2006
57 × 27 × 17 cm
Glass
Photo: Jackson Smith

Jon Kuhn works in cold
glass that is cut, polished
and fused into myriad shapes
from the inside out. The result
is a sculpture that takes in
surrounding light, then reflects
and retracts it back into space
much like a fine diamond.
Jon Kuhn's work has been
featured in over 30 international
museums including the
Metropolitan Museum of Art,
The Carnegie Museum, White
House Permanent Collection,
National Museum of American
Art and hundreds of private
residencies and public spaces.

Raglan Gallery

Raglan Gallery provides collectors worldwide with access to an exciting and diverse range of contemporary Australian art. It is located at Manly, a seaside resort on Sydney Harbour. The gallery has a long-term commitment to introduce and promote the best of Australian artists.

Staff
Jan Karras, Director
Caroline Arena, Staff

Artists represented
Clare Belfrage, Glass
Stephen Bowers, Ceramics
Mathew Curtis, Glass
Avital Sheffer, Ceramics

Contact
5–7 Raglan Street, Manly
NSW 2095, Australia
Telephone: +61 (0) 2 9977 0906
Fax: +61 (0) 2 9977 0906
Email: jan@raglangallery.com.au
www.raglangallery.com.au

Stephen Bowers
Decorated Platter 2005
Diameter 60 cm
Ceramic
Photo: Grant Hancock

'I seek to create contemporary Australian works that are both useful and provocatively decorative. I am interested in the modern ability to look back and re-contextualise stories, interpret meanings and examine the legacy of traditions. As well as studying Australian landscape and its biological and zoological information I explore Australia's diverse and multi-form human culture. I am interested in imaging possible histories and bringing together unexpected conjunctions of ideas, images and stories.'
Stephen Bowers

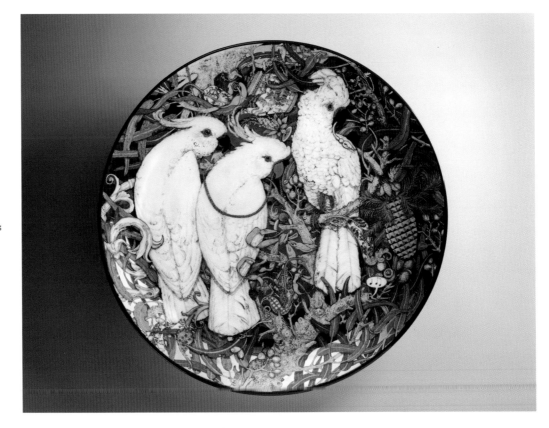

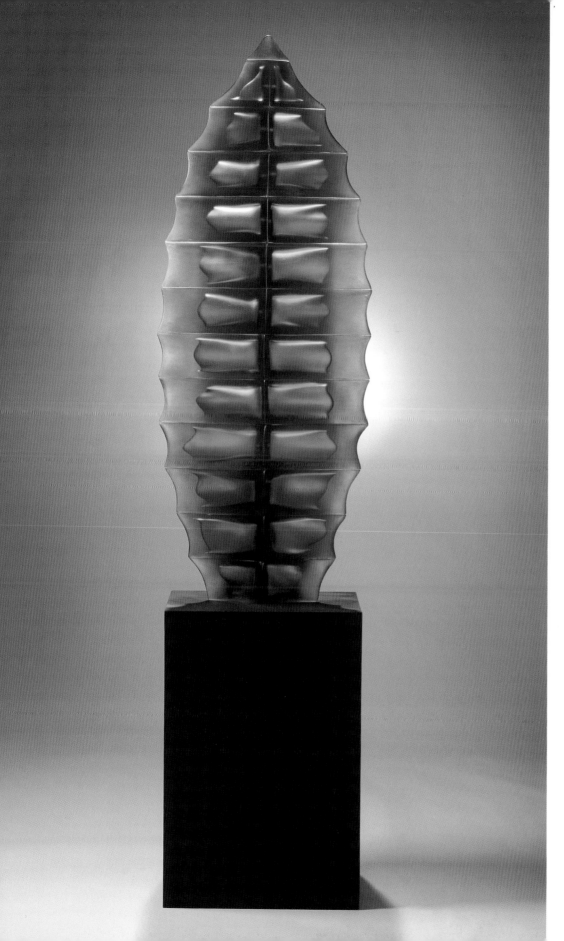

Mathew Curtis
Amber Carapace 2007
185 × 48 × 32 cm
Glass
Photo: Rob Little

'The scale and form of
Mathew Curtis's glass structures
continue to mutate as if by
quantum leaps into loftier and
uncharted dimensions. Through
a combination of blown and
moulded glass, as well as cold-
working techniques, Curtis has
achieved a hybridisation of the
glassmaking process which
has resulted in forms that allow
for a simultaneous examination
of internal and external
morphology. Each segment
captures a space within a bubble
membrane.'
Shane Giles (*Crafts Arts
International*, 69, 2007, 44–48)

Sarah Myerscough Fine Art

In conjunction with the fifth major exhibition of the world's most renowned wood-turners held at the gallery, Collect will feature a cross-section of new and innovative works by those artists. The outstanding quality of the work, and the sensitive and inventive use of materials, reveal the inherent beauty of wood. These exquisite fine art objects continue to inspire and captivate collectors worldwide. Our focus this year is on the Irish wood-turner Liam Flynn.

Staff
Sarah Myerscough
Suzanne McDowell
Dan Seymour-Davies
Brian Smouha
Hana Smouha
Andy Stewart

Artists represented
Gianfranco Angelino
Christian Burchard
David Ellsworth
Liam Flynn
John Jordan
Merete Larsen
Martin and Dowling
Philip Moulthrop
Marc Ricourt
Mike Shuler

Contact
15–16 Brooks Mews, Mayfair
London, W1K 4DS, UK
Telephone: +44 (0) 20 7495 0069
Fax: +44 (0) 20 7629 9613
Email: info@sarahmyerscough.com
www.sarahmyerscough.com

Liam Flynn
Inner Rimmed Vessel 2007
17 × 19 × 19 cm
Whitewashed ash
Photo: Liam Flynn

In 2005 the first Crafts Council of Ireland bursary was awarded to Liam Flynn, where his work was praised as 'world class' demonstrating his professionalism and creative vision. Liam specialises in making hollow-form vessels and is recognised by his peers as one of the leading exponents in his field. Galleries in the USA, UK and France are increasingly showing his work, and he has had representation in prestigious shows, such as *Sculptural Objects & Functional Art (SOFA)* in Chicago and New York.

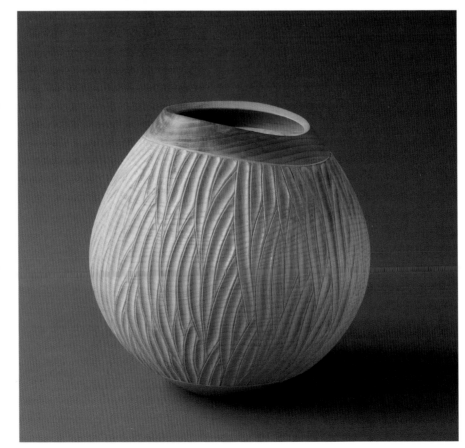

Marc Ricourt
Wild Cherry 2007
25 × 21 × 21 cm
Cherry-wood, ferrous oxide
Photo: Mark Ricourt

Marc Ricourt studied for three years at Dijon Fine Arts School, but as a wood-turner is largely self taught. This fine Art background has allowed him to combine the traditional vessel form with conceptual and sculptural concerns. The utilisation of unrefined materials, such as iron oxide, reinforces the sacred and symbolic nature of the work and retains a sense of purity as he strives to discover a perfect harmony between shape, texture and colour. Ricourt has exhibited internationally at locations such as Chicago, Los Angeles, Geneva, Paris and Luxembourg, as well as Sarah Myerscough Fine Art, London.

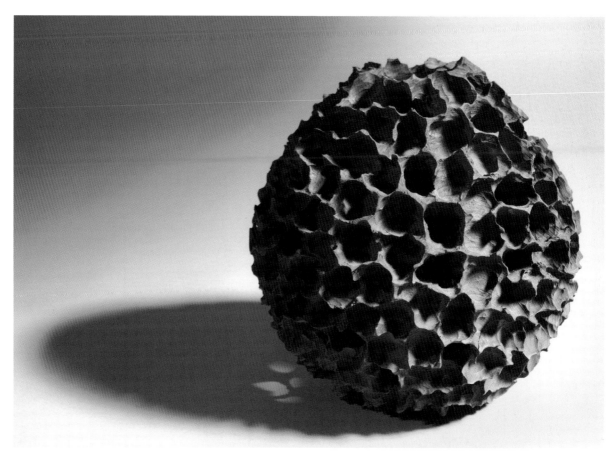

The Scottish Gallery

The Scottish Gallery, established in 1842, are specialist dealers in contemporary British ceramics, metalwork and jewellery and twentieth-century Scottish painting. The gallery has changing monthly exhibitions and holds a wide-ranging stock.

Staff
Christina Jansen
Amanda Game
Rupert Johnstone
Robin McClure
Ruta Noreika
Diane Shiach

Artists represented
Stephen Bird, Ceramics
Peter Chang, Jewellery
Susan Cross, Jewellery
Jack Cunningham, Jewellery
Dorothy Hogg, Jewellery
Takahiro Kondo, Ceramics
Bodil Manz, Ceramics
Grant McCaig, Silver
Judy McCaig, Jewellery
Jacqueline Mina, Jewellery
Stephen Newell, Glass
Jim Partridge, Wood
Frances Priest, Ceramics
Wendy Ramshaw,
Glass/Jewellery
David Reekie, Glass
David Roberts, Ceramics
Norma Starszakowna, Textiles

Contact
16 Dundas Street
Edinburgh, EH3 6HZ
Scotland, UK
Telephone: +44 (0) 131 558 1200
Fax: +44 (0) 131 558 3960
Email: mail@scottish-gallery.co.uk
www.scottish-gallery.co.uk

Takahiro Kondo
Black/Yellow Mist Box 2007
Height 19.5 cm, width 21.5 cm
Porcelain, cast glass
Photo: Ruth Lock

Takahiro Kondo combines his deep-rooted understanding of porcelain as a third-generation Kyoto artist with a wide-ranging artistic vision to create new, painterly vessel forms, often incorporating cast glass.

Wendy Ramshaw
Universe 2007
Height 48 cm, diameter 46 cm
Clear, frosted, white glass
Photo: Graham Pym

Residencies at St John's College, Oxford, and Pilchuck Glass School in Seattle in 2005–6 gave Ramshaw an opportunity to explore new ideas in glass, resulting in multiple-part installations inspired by the history of science and the beauty of manmade structures.

West Dean Tapestry Studio

West Dean Tapestry Studio promotes the art of tapestry through the accomplished production of commissioned work. Our team of artists includes established makers and rising new talents who work with architects, corporate bodies and private clients to create individual works of art.

Staff
Pat Taylor, Director of Tapestry
Caron Penney, Head of Tapestry Studio
Philip Sanderson, Creative Director

Artists represented
Jo Howard
Caron Penney
Philip Sanderson
Katharine Swailes
Pat Taylor

Contact
Edward James Foundation
West Dean, Chichester
West Sussex, PO18 OQZ, UK
Telephone: +44 (0) 1243 818 233
Fax: +44 (0) 1243 811 343
Email: caron.penney@westdean.org.uk
www.westdean.org.uk/tapestrystudio

Caron Penney, Katharine Swailes, Jo Howard
Citrus Sinensis – triptych 2007
50 × 170 × 5 cm
Working design for tapestry weaving
Photo: West Dean Tapestry Studio

Caron Penney, Katharine Swailes and Jo Howard are jointly producing a triptych for the Collect 2008 show. The work brings together three personalities combined to produce these contemporary works of art influenced by late Renaissance tapestries in Europe. In this new exploration flavour is given through the reworking of the colour palette, the use of line and the exploration of graphic qualities that suit a contemporary setting.

Pat Taylor
Portrait of a Man (detail) 2007
$114 \times 114 \times 5$ cm
Tapestry weaving, cotton, wool
Photo: Steve Speller

'This image of a man who lived at the turn of the twentieth century is the second of a portrait series that seeks the fleeting yet palpable presence of the individual.'
Pat Taylor

As a practising tapestry weaver for over 30 years Pat Taylor exhibits regularly both nationally and internationally and is currently tutor to the Postgraduate Diploma in Tapestry Weaving at West Dean College/University of Sussex. In 1996 she became the Director of the commission-based tapestry weaving studio in West Dean in West Sussex, England.

Yufuku Gallery

Yufuku represents contemporary Japanese artists who embrace tradition, yet instil their works with a cutting-edge aesthetic. In particular, Yufuku places emphasis on innovative artists whose works define, enhance and transform space.

Staff
Tom M. Aoyama, Owner
Maki Yamashita, Gallery Representative
Wahei Aoyama, International Director
Namiko Aoyama, Assistant

Artists represented
Masahiko Ichino, Ceramics
Ken Mihara, Ceramics
Shigekazu Nagae, Ceramics
Mutsumi Suzuki, Lacquer
Naoki Takeyama, Cloisonné
Takahiro Yede, Metal

Contact
Annecy Aoyama 1st floor
2–6–12 Minami-Aoyama
Minato-ku
Tokyo 107–0062, Japan
Telephone: +81 (3) 5411 2900
Fax: +81 (3) 5411 2901
Email: wahei@toku-art.com
www.yufuku.net
www.toku-art.com

Mutsumi Suzuki
Vermilion-lacquer Mukozuke Bowl 2007
Height 7.5 cm, diameter 15 cm
Lacquer, Keyaki wood
Photo: Kazumi Kurigami

'The masters of old never attempted such a radical form, yet they too had wood bases carved to 0.3 millimetres in thickness. As heated water boils and ultimately turns to steam, this new form was also a natural progression. With innovation, I feel as if I'm truly giving birth.'
Mutsumi Suzuki

Ken Mihara
Kigen07 2007
34.5 × 54.5 × 16 cm
High-fired stoneware
Photo: Tadayuki Minamoto

'To first imagine and then to
complete a work is a long
journey. One may think he
himself is guiding the journey,
only to find that it is he who is
being guided. Such a journey
is unforgettable. This work was
such a journey.'
Ken Mihara

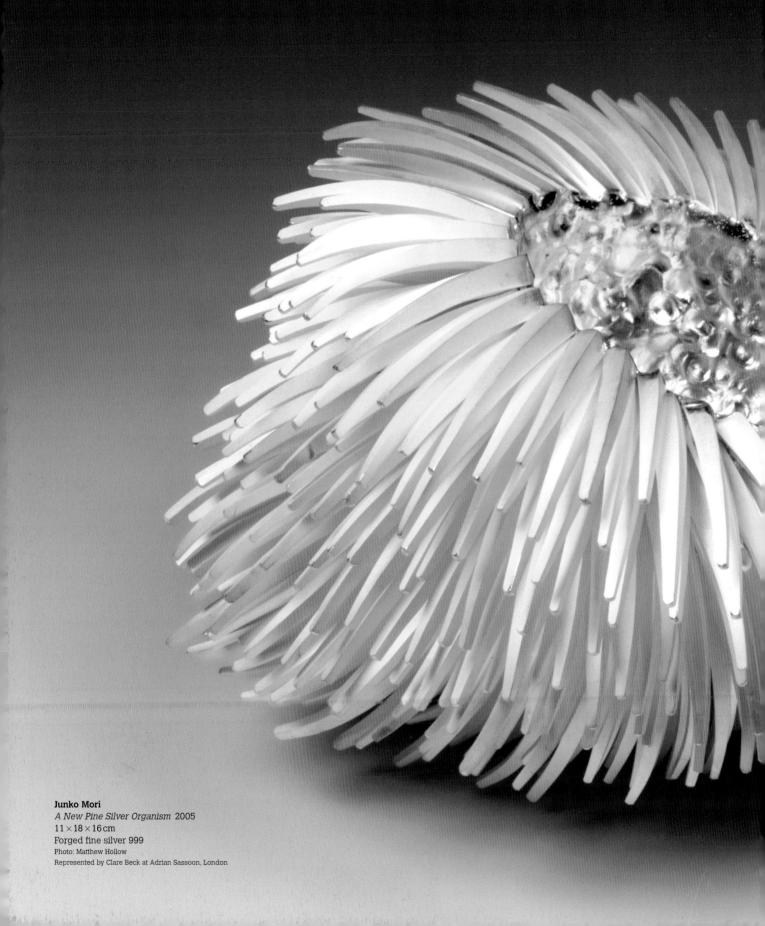

Junko Mori
A New Pine Silver Organism 2005
11 × 18 × 16 cm
Forged fine silver 999
Photo: Matthew Hollow
Represented by Clare Beck at Adrian Sassoon, London

Indexes

General Index

Artists Index